PRAISE FOR *Snow Fleas and Chickadees*

"Reading this graceful, engaging book made me feel as if the hurried, fragmented world had finally slowed down long enough for its finest secrets to be revealed. Eve Quesnel's endless curiosity leads her to fascinating questions—and even more astounding answers—that enrich our understanding of the Sierra Nevada. In addition to being an elegant, illuminating journey into nearby nature, *Snow Fleas and Chickadees* offers an inspiring reminder that close attention to the more-than-human world can be a form of praise. Quesnel's book will be a delightful literary companion to any Sierra stroll."

—Michael P. Branch, author of *Raising Wild*
and *On the Trail of the Jackalope*

"Our community is infinitely more ingenious, colorful, and peculiar than we may realize. This engaging illustrated companion introduces twenty-one furred, feathered, leafy, and easily overlooked residents of the Sierra Crest, whom Quesnel calls dear friends. Thanks to her delightful guide, we too can get to know and love our neighbors in nature."

—Cheryll Glotfelty, editor of *Literary Nevada: Writings from the Silver State*

"*Snow Fleas and Chickadees* is a delightful romp through California's Sierra Nevada with a friendly, knowledgeable guide, examining not just the megafauna—bears and coyotes—but everyday wonders, such as algae and ants, fungus and fleas. This lovely book is the perfect companion whether out on a multi-day trek or a backyard amble and has therefore earned a permanent place in my backpack."

—Suzanne Roberts, author of *Almost Somewhere: Twenty-Eight Days on the John Muir Trail*

"Identifying plants and animals we encounter in nature is fun and challenging but it is only the start of a naturalist's world. Wild things have amazing stories. Learning these stories adds richness and wonder to our world. In *Snow Fleas and Chickadees*, Eve Quesnel and Anne Chadwick pull back the curtain and share tales that will fill you with joy and awe. This book will deepen your appreciation and love of nature as you explore the Sierra Nevada."

—John Muir Laws, *The Laws Field Guide to the Sierra Nevada*

"In *Snow Fleas and Chickadees*, Eve Quesnel shows us how to view the world of mountain nature through her eyes. Her species descriptions are one of the many highlights

of the book. Readers will want to pick this one up and read it cover to cover, it's that engaging!"

—Tim Hauserman, author of *Going It Alone: Ramblings and Reflections from the Trail*

"Take this book, find a cozy well-lit place along with the warm comfort-drink of your choice, and start turning pages. Venture forth with Eve Quesnel to, as she puts it, "Take a morning coffee walk." Whether in the dark of winter's dawn, square shouldered against ice stinging winds, or strolling her neighborhood, sun spangled and bustling with life, she invites you to join her as she observes the natural world around her. Questions she might have flow through accounts, along with gem-like nuggets of information about a myriad of subjects and characters, all having to do with the Sierra Nevada. Adorned with refreshingly animated illustrations by Anne Chadwick, this book celebrates the wonders to be found when we venture forth, slow down, and pay attention. For this gift of her unique perspective, we should all be thankful."

—Keith Hansen, author of *Hansen's Field Guide to the Birds of the Sierra Nevada*

"I've been on walks with Eve, shared her coffee, hugged her mutts, and relished many of the treasures she has discovered so very close to home. *Snow Fleas and Chickadees* opens her Sierra Nevada treasure chest for any reader who cares to join her on her daily jaunts. Please do—you'll love every step of the way."

—Ann Ronald, professor emerita of English, Foundation Professor, University of Nevada, Reno

SNOW FLEAS AND CHICKADEES

SNOW FLEAS
AND CHICKADEES

Everyday Observations in the Sierra

EVE QUESNEL

WITH ILLUSTRATIONS BY
ANNE CHADWICK

University of Nevada Press | Reno, Nevada 89557 USA
www.unpress.nevada.edu
Copyright © 2025 by University of Nevada Press
All rights reserved

Manufactured in the United States of America

FIRST PRINTING

Jacket design by TG Design
Jacket illustrations by Anne Chadwick

Library of Congress Cataloging-in-Publication Data
available upon request.

ISBN 978-1-64779-189-6 (cloth)
ISBN 978-1-64779-190-2 (ebook)
LCCN: 2024038735

The paper used in this book meets the requirements of American
National Standard for Information Sciences—Permanence of Paper
for Printed Library Materials, ANSI/NISO Z39.48-1992 (R2002).

*This book is dedicated to
students and professors who study and research
the natural world,
writers and journalists who write on nature,
lawyers and policy makers who design policies to protect the
environment,
activists who advocate for the land, creeks, rivers, oceans,
plants, and critters of all kinds,
educators who expose children and adults
to the outdoors,
and recreationists who recreate ethically.*

*To all who give voice to the natural world so that we may value
its processes and do what we can to let it thrive,
I devote this modest book.*

> There is never an end to observing nature on its own.
>
> —Poet, essayist, and environmental activist Gary Snyder

Contents

Preface
Diorama—Through That Which Is Seen 1

Birds

Chapter 1. Mountain Chickadee (*Poecile gambeli*) 13

Chapter 2. Northern Pygmy Owl
(*Glaucidium gnoma*) 19

Chapter 3. Sooty Grouse (*Dendragapus fuliginosus*) 25

Chapter 4. Common Raven (*Corvus corax*) and
American Crow (*Corvus brachyrhynchos*) 31

Chapter 5. White-headed Woodpecker
(*Dryobates albolarvatus*) 39

Animals

Chapter 6. Coyote (*Canis latrans*) 47

Chapter 7. American Black Bear (*Ursus americanus*) 55

Chapter 8. Douglas Squirrel (*Tamiasciurus douglasii*) 63

Chapter 9. American Pika (*Ochotona princeps*) 69

Plants

Chapter 10. Quaking Aspen (*Populus tremuloides*) 77

Chapter 11. White Fir (*Abies concolor*) and Red Fir (*Abies magnifica*) 83

Chapter 12. Woodland Pinedrops (*Pterospora andromedea*) 89

Chapter 13. Needle Drop 95

Mushroom, Algae, Rock, Arachnid

Chapter 14. Shaggy Mane Mushroom (*Coprinus comatus*) 101

Chapter 15. Watermelon Snow Algae (*Chlamydomonas nivalis*) 107

Chapter 16. Glacial Erratic 115

Chapter 17. Orb Web 121

Amphibian, Insects

Chapter 18. Sierran Treefrog (*Pseudacris sierra*) 129

Chapter 19. Western Amazon Ant (*Polyergus mexicanus*) 135

Chapter 20. Snow Flea (*Hypogastrura nivicola*) 141

Chapter 21. Pale Swallowtail Butterfly
(*Papilio eurymedon*) 147

Afterword 153

Acknowledgments 159

Bibliography 163

About the Author and Illustrator 175

SNOW FLEAS AND CHICKADEES

Preface

Diorama—Through That Which Is Seen

> Yes, the world is overheating, and yes, we
> will get to that; but how about—before the
> flames of apocalypse consume the planet—
> we explore our own neighborhoods a little?
>
> —David Gessner, *My Green Manifesto*, 2011

EVERY DAY BETWEEN 6 and 7, I take a walk—I call it my morning coffee walk. It's how I meet the dawn in my neighborhood at six thousand feet in the Sierra, or, to note it in bioregional terms, my coffee walk takes place in the Truckee River Watershed defined by the Truckee River and its tributaries that flow from Lake Tahoe, California, to Pyramid Lake in Nevada. During that hour, I head out the door, dressed for whatever weather greets me, with whatever dogs I have in tow, surrounded by the tall timber of firs and pines and the lower-growing sagebrush, bitterbrush, and tobacco brush.

No matter how hard it's raining or snowing, no matter the intensity of the wind that forces my head to

bend toward the ground, I am like the postal worker or UPS driver: I get out there. Bundled up—for Sierra winters seem to take up most of the year—I place my binoculars in one pocket of my down coat, put one of my fleece-gloved hands into the other, and wrap my remaining gloved hand around a warm coffee cup. Before leaving, I turn to the pack—the yellow Labrador, pit bull mutt, and cattle dog—who have been waiting patiently on their dog beds. "Let's go," I say. But they already knew what was coming; they had heard the kettle whistling, seen the steam rising from the coffee filter, had already watched as I headed to the mud room to pick up an old pair of tennis shoes or heavier boots. Equipped with a gray wool Canadian hat and my phone in case I want to take a picture . . . and we're off.

I live on a cul-de-sac, which means my daily coffee walk is a mere one block long. My longer walk—the *real* walk, so to speak—takes place in the late afternoon in a forest on pine needle paths. But in the morning my mutts and I saunter down the street in no hurry *because* it's only one block. We have time. With vacant lots along the way we also have plenty of room to roam.

My street, framed by five- to eight-story ponderosas

and white firs, seems more like a tunnel than a road, and I often imagine myself in a painting—a bulky being hunched forward to take on the weather, three dots darting in and out of the woods. Call it *Blurry Figures on a Woodsy Street* or *Walking with Noticing*.

Our sauntering is most often interrupted when something catches our attention: a bright color, a loud sound, a pungent smell. Each dog finds his or her own path into the forest on the sidelines, as do I. If it's an object on the ground, I'll squat down, bending my knees. If it's above, I'll arch my head back. Eye level, I'll lean in. During these pauses, observing nature, I am completely engrossed. Living in the present could not be more relevant than in these moments. From these sporadic diversions, oh, the things I have seen!

One morning in a winter blizzard, I witnessed a bobcat crouching behind a boulder, certain I wouldn't see it or its black ear tufts sticking out above the rock. Another time, a black bear and her two cubs lumbered across the street, in no hurry for the day. Bright red snow plants, the shape of swirling frosty cones, push their way up through hard dirt and duff in the spring, as do the phallic shaggy mane mushrooms in

the fall. Chickadees perform circus acts by hanging upside down on fir branches, pecking at berries and insects on the underside of leaves. Every month, I am amazed by the way the full moon casts tree shadows on the pavement, like black cutouts pasted onto the street.

One afternoon, typing away on my computer upstairs, I heard a loud *kre-ak* from below. After running downstairs and opening the door, I saw in one of the dog dishes the tiniest of frogs, a Sierran treefrog the size of a quarter, struggling to climb out of the slippery basin. I picked it up and placed it on a piece of granite that looked exactly like it did: granite gray with flecks of black and white.

In the summers, my husband and I sleep outside on our back deck on a foam pad with flannel sheets and a down comforter. We watch the stars and the moon's phases and listen to whatever serenades us in the night—mostly coyotes—and at first light of day robins, jays, chickadees, and nuthatches. The cold wind brushes our faces and bends the towering treetops above us; we listen to the gusts *whir* in the treetops like a train in the distance. In late fall, we fight the urge to move indoors, to become interior beings

again, but we eventually lose the battle once the comforter gets stiff from frost or a surprise blizzard overlays our covers with a blanket of fresh snow.

Yes, one can achieve a sense of place when the outside becomes as comfortable as the inside, when one gets to know the lay of the land, the flowers, the trees, the birds. But it's more than that. We begin to learn all that lies within an ecosystem: a diorama, so to speak. In each diorama—meaning "through that which is seen"—we view a transect plot, a section highlighted for purview. In one, a patch of dirt, a pile of pine needles, a tiny frog. In another, a broader scene—a snowstorm, a swooping raven, a tunnel of snow-frosted white firs. Just as dioramas in a natural history museum display one section from a much larger landscape, we can learn about the natural world in contemplating smaller spheres.

On one of my first coffee walks, a bright yellow and orange flash streaked across my path. I quickly pulled out my binoculars to marvel at the seemingly lost tropical bird. When a western tanager lands in a pine it becomes swallowed by thick fir branches, yet peeps of bright yellow and orange gleam beyond the dark green needles. I look up, the trees like towers,

several cumulous clouds hanging in the sky. I become the lens, seeing the relation of one thing to another. A sense of space, and everything in it.

During yet another morning ramble, on a frosty October morning, I walked maybe ten steps down the street and almost disturbed a spider's web, one thin thread stretched from one side of the street to the other, as if someone had carefully tied a string. Hanging from the frozen filament, a row of icicle droplets seemed as if they had been deliberately placed in a certain order with a specific design, giving the appearance of a diamond necklace suspended in midair. The diorama looked like this: an aspen tree offers an anchor on one side of the street, a white fir an anchor on the other. A thin thread hangs between them. Frozen droplets bearing weight cause the thread to bend and droop. My eyes, the exact height of the web, stare at the frozen diamonds that reflect the trees, the sky, and me in its mirrors. I stand for a long time, mindful that the scene is temporary, knowing the diorama will soon disappear when the droplets melt and the thread is crossed and broken.

As I walk each day on my cul-de-sac and then later on the longer afternoon loop, I ponder the most basic

of questions: *How does a spider spin such a long line? Why are all those ants lined up in a row, carrying what looks like grains of rice down the hill and into the forest? What is the name of that bird that sings "chewy, chewy, chewy" all summer long?* When I hear a symphony of hundreds of sandhill cranes above me, I wonder where they're going and where they've been. Cross-country skiing in January, I spy hundreds of tiny black specks in the snow, moving, actually jumping! Snow fleas! *How did they get there?*

Questions, always questions.

And then answers.

Answers provide not only the name of a thing but a little something about it. It is this "un-peeling" of layers in nature that opens up our world.

The motivation for this book began with one more question: *Might others want to know a little something about their own neighborhoods?* This simple inquiry inspired "Nature's Corner," a column that addresses Sierra flora and fauna in the local North Lake Tahoe-Truckee newspaper, *Moonshine Ink*. At some point, after having written numerous articles, it seemed only natural to let the writings live next to one another in a collection, many things in nature being connected in some way.

Looking back at my research, I am reminded of the many professionals whose enthusiasm I came to inherit; I depended on them. For I am not a biologist, ornithologist, entomologist, or arborist. I am not an "ist" of any kind. I am a casual observer curious about the natural world. Those who I contacted were extremely knowledgeable, passionate, and caring. For example, the barrage of emails I received from professors and graduate students studying ants, and the hours I spent talking to graduate students who researched the chickadee. One student wore a tattoo on the underside of her forearm that read *chick-a-dee-dee*, with a graph above illustrating the musical notes associated with the song of the bird. I am forever thankful to those who contributed to my understanding of some of nature's complex processes.

But my interest in the natural world began long before I started writing about it, decades ago, in fact. In the early 1970s, I enrolled as one of the first two students in the Yosemite Institute's inaugural year. During the program, we learned of the indigenous people of the valley, cross-country skied over frozen Mirror Lake, and were taught about geology, plants, animals, and wildland forest fires. I was entranced

from the get-go—stunned and mesmerized by Yosemite's stark granitic beauty. After Yosemite, when I was in my twenties, I put on a Forest Service uniform and joined the ranks of backcountry rangers, carrying my life in a pack for a week, exploring more of the Sierra I was growing to know and love.

In that first job, as much I loved the outdoors, I didn't care to know the names of things; I didn't see the significance in identification. *What was the purpose? Why does it matter? I admired and appreciated nature. Wasn't that enough?* In my second backcountry job, in the Sawtooth range in Idaho, I began to learn the value of labeling. When you name something, you notice it more. Mountain bluebirds flying at the edge of a meadow. Shooting stars lining a creek. Bright red snow plants emerging through dirt. Watermelon snow. In naming a thing, one becomes familiar with what was unfamiliar, notices what was seemingly hidden before. Further than that, with a little research a kinship grows.

The Sierra Nevada, in Spanish, means "snowy mountain range," and so this is where I begin my exploration and identification . . . on a snow-covered street. Later in the spring I follow creeks that flow into rivers, rivers into lakes. Summer beckons

higher-elevation walking, and fall requires bundling up and noticing all that prepare for an impending long winter. In my neighborhood, I am surrounded by woods, yet in cities too, plants find their way, emerging from sidewalk cracks, just as birds make their homes in metropolitan areas, building nests on city rooftops. California poppies pop up in the Sierra but also show a colorful display on hillsides by the ocean. Nature is everywhere, in an array of dioramas.

Birds

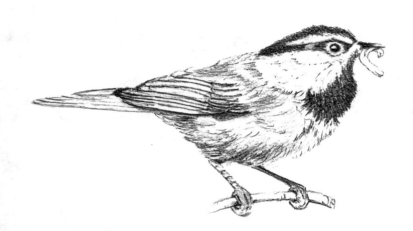

CHAPTER I

Mountain Chickadee
(Poecile gambeli)

SURE, YOU COULD take the easy way out. You could head down south when the temperature drops, when you reach for your down coat and wool hat, when you start dreaming of surf and sand and blended drinks with paper umbrellas. You could leave the dark, cold winter behind and take flight. Or . . . you could stay, just like the white, black, and gray bird, the size of a junco, smaller than a sparrow, the one with the black Zorro mask.

From my kitchen window, I watch this winter survivor all year long. Three terra cotta plant saucers filled with water, set on the ground below a group of white firs, offer the perfect viewing point to watch the busy "cheeseburger" bird, drinking and bathing. Zipping back and forth, the mountain chickadee seems not to fly but rather to fall at great speed. I look for the quick flash and then the splash of water splatter from the plates. *Dee-dee-dee, cheeeeese-burger, cheeeeese-burger*, it

sings. In the winter, I watch them congregate at the frozen baths as if gathering at an ice-skating party. When they return to the firs, I notice the occasional snowflake settled on top of one's gray head.

Unlike the western tanager, Wilson's warbler, Calliope hummingbird, house wren, American robin, and many other Sierra birds that migrate south for the winter, this hearty *carbonero montañés* (Spanish for mountain chickadee) remains. Thick plumage and body heat emanating from a mated pair nestled in their cup-nest, created in a woodpecker hole or other small opening, keep them warm and protected. Such warming factors allow the winter chickadee to enter a "torpor" state, or "temporary dormancy," reducing breathing, body temperature, and metabolism. But when the woods become covered with multiple feet of snow, one can't help but wonder where its food source lies.

Much like we stockpile our pantries, chickadees fill their cupboards. From September through November, the little Zorro gathers Jeffrey and lodgepole pine seeds—and western white pine and mountain hemlock at higher elevations—and stores them in hiding places called caches. To glean the seed from a

cone, it reaches between the cone scales and pulls the winged seed out; the wing helps it fly in the wind. It also collects seeds that have fallen on branches from already opened cones and then caches the seeds in cracks or holes or the underside of bark, relatively close to where it found them. It's been said that this little acrobat can cache up to a thousand seeds in one day, with a potential haul of tens of thousands in a single fall season.

But how does this masked marvel remember the location of so many hiding places?

The answer lies in the most remarkable part of its winter survival—its memory, spurred by "spatial location." Chickadees remember landmarks in the landscape in relation to other nearby landmarks, such as recollecting the exact location of a specific group of trees. After finding the cache, it takes the conifer seed to a safe location away from its competitors—nuthatches, Steller's jays, even other chickadees—to eat its meal in private. Whether they eat half or more of what they cache is unknown, but it is known that these resourceful birds over-cache relative to their needs.

Although seed gathering is the most marvelous feat, its short, sharp beak, plus its ability to hang

upside down, offer additional food opportunities. Other than cracking open small seeds with its sharp implement, the beak grabs insect eggs, insect larvae, and spiders found on the top *and* bottom of branches, and in cracks in tree bark. In their frenzied activity in the spring, the parent flies incessantly from trees to nest, feeding their six to eight chicks, mouths wide open and squawking at the entrance of the nest, for about three weeks until the fledglings fledge.

The average mountain chickadee's lifespan is one and a half years. The highest mortality occurs in juvenile birds during their first winter. If one can't remember where its food is cached, it is not likely to survive.

There's solace in knowing the *Poecile gambeli* remains in the Sierra in the winter. There's a tradition in it, a reliability. Its intelligence and fortitude (and memory!) speak to ingenuity. This small acrobat that can hang upside down like a trapeze artist is truly a remarkable bird. Practical, resourceful, diligent, and skilled, the mountain chickadee reveals a tenacious side of nature.

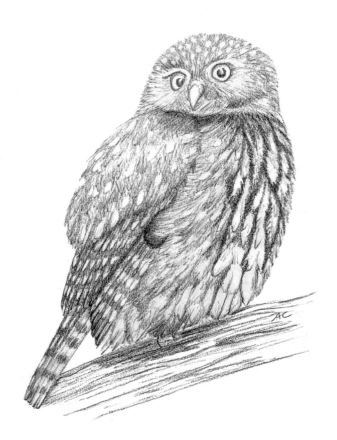

CHAPTER 2

Northern Pygmy Owl (Glaucidium gnoma)

I DIDN'T SEE it, but I *did* hear it—a pied piper in the night playing a hollow flute, "tooting" in the depths of the dark deep forest. I first heard it while walking down my street between afternoon and evening, the *crepuscular* time. Then I heard it for hours longer. It was repetitious and loud, two toots with a pause. I asked my neighbor what nocturnal bird could have been calling all night into the black dim void, to which she replied: "There is no mistaking the identity. It's a northern pygmy owl. I've heard it for years."

As its name implies, the northern "pygmy" is small in comparison to most owls: tiny, in fact, a mere seven inches in length, its wingspan twelve to fourteen inches, weighing in at a little over two ounces, the size of a robin. Other than its diminutive size, the pygmy is unmistakable in its spotted and striped plumage. White spots dot its brown head; vertical brown brush strokes line its white chest. If you're lucky enough to

see one perched on a tree, you might even notice its extended brown tail cocked to one side, barred with streaks of white horizontal lines. Overall, this small owl can be described as a small oval bird or a puff ball the length of one's hand.

An interesting component of nature is adaptation, how an organism adjusts to its environment to become better equipped to survive; owls are a prime example of this. Their ears, eyes, and head all take part in facing their adversaries in the natural world.

I have learned many surprising facts about owls, the most unexpected involving their ears. What I had always thought were ears, clumps of hair standing on an owl's head, aren't ears at all. One usually conjures the statuesque great horned owl when considering ear tufts—in this case, its two large furry horns. Unlike the great horned, though, the northern pygmy owl's tufts are hidden until it senses danger. At that time, it raises its tufts, barely noticeable, more like it's raising its eyebrows. It does this like a dog raises hackles on its neck and back. These ear tufts resemble twigs or branches, thereby providing additional camouflage to their already matching feathers, unseen against tree bark.

Owls' *true* ears are hidden, covered with feathers where ears are usually located. If the feathers are moved to the side, one can see a fleshy oyster apparatus, like the mucous part of a cornea.

Nocturnal owls, such as the barn owl, have asymmetrical ears, meaning one is placed higher than the other. This placement helps the owl pinpoint the source of a sound, usually its prey. The owl hears a sound in one ear, turns its head until the other ear hears the sound, and voilà, the connection is made from a vertical axis. The pygmy owl, however, because it's *diurnal*, active both day and night (and because it has the ability to depend on vision), has more symmetrical ears. They hear the slightest movement in leaves or undergrowth or even under snow.

Another adaptation is owls' flattened facial discs. Like a satellite dish, the flat disc funnels sound to the ear openings. But the pygmy owl, once again, because it is out and about in the daytime, lacks such a body part.

To its glowing yellow eyes, a third eyelid—besides the upper and lower—is added, called the *nictitating membrane*. Like a windshield wiper, it intermittently closes diagonally to protect and clean the eyes. At night, the

big black pupils enlarge to let in ample light for hunting. One of the most distinguishing marks of a pygmy is its false eyes. At the back of its head a second pair of "eyes," two black circles fittingly called *eye spots*, seem to watch as well. A predator may be watching its owl prey, but which direction does the owl face?

Lastly, because owls have limited eye movement, they instead have the ability to turn their heads to watch for predators. Not a full 360 degrees, but they can revolve 270 degrees in both directions. This amazing feat is possible because of fourteen neck bones and a supporting vascular network that helps minimize any interruption in blood flow. When the pygmy turns its head, the eye spots seem to stare from the front while its real eyes seem to stare from the back.

Other than a pygmy's adaptive ways, how it gains its nutrition is remarkable as well. As is the case with other birds of prey or raptors, the nondigestible parts of an owl's catch (birds can make up one-third of the northern pygmy's diet)—fur, feathers, and bones—are packed into sausage-shaped pellets. Approximately ten hours after consuming its meal, the owl regurgitates the pellet of undigestible waste.

After that process, the owl can hunt again, absorb more nutrients from its next meal, and regurgitate once more. Finding pellets is a good clue that an owl might be lurking nearby.

The pygmy's diet is composed of small songbirds such as sparrows and finches, and larger birds such as thrushes and robins, but it also feeds on moths, beetles, and grasshoppers as well as voles, chipmunks, frogs, and bats. Surplus prey is cached in tree cavities in both winter and summer. This tiny owl's diet is diverse! But how does such a small bird capture its larger meals? Known to be an aggressive hunter, the pygmy grabs its prey with its talons and snaps the neck with its beak. Lesson learned: never underestimate the capabilities of the bird named for its diminutive size.

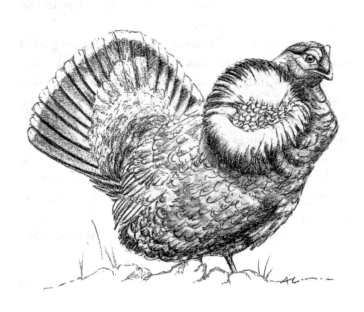

CHAPTER 3

Sooty Grouse
(Dendragapus fuliginosus)

> One touch of nature makes the whole world kin;
> and it is truly wonderful how love-telling the
> small voices of these birds [grouse] are, and how
> far they reach through the woods into one anoth-
> er's hearts and into ours. The tones are so per-
> fectly human and so full of anxious affection, few
> mountaineers can fail to be touched by them.
>
> —John Muir, *Our National Parks*, 1901

AH, THE SOUNDS of spring. Bees buzzing, chickadees *chicka-dee-dee-ing*, jays squawking, and a low *woomp... woomp... woomp*. Like the sound produced by blowing across the top of a bottle. Like an owl's hoot at low frequency. Like a muffled echo.

The sooty grouse's reverberation heard throughout the forest is a marvelous sound of nature, but the grouse itself is rarely seen. It cryptically perches high in the trees, sometimes up to one hundred feet, even

though it's a large bird, the size of a chicken. On the ground, it walks or scurries if threatened, but is not any easier to see. The male's "sooty" plumage, gray-blue feathers with a contrasting light gray band at the end of its black tail, camouflages it well, as does the female's subtle brown mottled feathers.

Come late April to early July, when the male struts its stuff by sounding off its mating call, the sooty grouse is not so covert. The *woomp* one hears in the depth of the woods, sometimes for hours, is quite loud, usually six deep-toned hoots that can carry as far as half a mile. This "hooting" is often likened to that of the great horned owl as the male grouse crows about, whether from the ground or high up in the pines and firs.

The male can call sometimes for hours, adding further displays to attract the opposite sex: fanning its tail upright like a peacock and/or strutting along tree branches. In addition, the male performs short fluttering flights out from a tree while sounding its low-pitched hoots. Females attracted by these displays often reveal themselves with a soft cackle, which causes the male to descend from the song post to the ground. Like Romeo and Juliet. Except in reverse. Romeo descends from the balcony, not his beloved one.

On the ground, the male grouse prances, its throat air sacs like a yellow-orange egg yolk within a circle of white feathers bellowing out and in. These *cervical apteria* or *cervical air sacs* look much like the bumpy hide of an elephant. At the same time, the grouse shows off its matching yellow eyebrows (*superciliary apteria*).

Mating commences; afterward, the male leaves.

The sooty grouse's nest, lined with twigs, needles, moss, and a few feathers, is made in shallow depressions on the ground near rock ledges, logs, or shrubs, and houses five to ten brown-spotted cream-colored eggs. Almost immediately, at about one day old, juveniles feed on their own, mostly insects. The female likely determines travel routes but does not feed juveniles or direct them to specific items of food. They're on their own. At about thirteen weeks, the young are fully grown.

Unlike many birds that migrate in the winter, this grouse remains behind or travels locally, no farther than thirty miles, moving by foot or in short flights (not a long-flying bird, it relocates in short bursts). What is most strange about this bird is its *altitudinal migration*, its sense to move higher in elevation in the winter, not lower, even as high as eleven thousand

feet. To survive such harsh conditions when the leaves, flowers, berries, and insects of the warmer season have disappeared, the grouse feeds on pine and fir needles, a more savory fare.

What a marvelous bird is the sooty grouse—if you can catch a glimpse of it, on its own or in a group of females scurrying about. More likely, you'll hear it.

Like a booming tuba. A thump on a jug. A baritone song.

Addendum: dusky versus sooty. The distinction between the dusky grouse (*Dendragapus obscurus*) and the sooty grouse (*Dendragapus fuliginosus*) might be a little confusing. A brief explanation claims their first identification was made separately by Lewis and Clark in the 1800s, but in the 1900s they were combined into one species called the blue grouse. It remained that way until 2006, when the American Ornithologists' Union decided to once again split the species into two separate groups.

There are two easy identifiers to distinguish the sooty from the dusky. The sooty grouse is found from Southeast Alaska south to Northern California (the Sierra and the Cascades). Dusky grouse are found in the interior western U.S. and Canada (Rocky

Mountains). The sooty's apteria are yellow; the dusky's apteria are red. Sooty's tail is black with a light gray band; dusky's tail is solid black. The distinctions are not always definitive, however, as certain characteristics can be switched in overlapping regions.

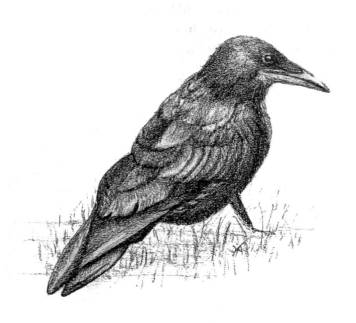

CHAPTER 4

*Common Raven
(Corvus corax)
and American Crow
(Corvus brachyrhynchos)*

WINTER BE DAMNED, common ravens might say, or perhaps it's "Nevermore" to warm and sunny days of summer. These noisy pretentious black birds that remain in the Truckee-Tahoe region all winter long are easy to spot. They can be observed high in the sky or atop a tree, or just as easily seen hopping or walking on the ground. Wandering down my street every morning, I sense the raven's curious gaze, as if it's saying, "Who are you, and what are you up to?"

The strangest encounter I had with this large black bird was the day before our Labrador-pit bull passed away. She had suffered a stroke, her balance off, her breathing heavy. My husband and I sat in the yard with her to keep her calm and quiet. That was the very strange day a raven joined us, my husband and

me and our dying furry family member, as if it were part of our little group. It never startled or took flight; it only walked with a sort of waddle within a mere ten to twenty feet of us. Even at the time I remember thinking, *Does the raven know something is going on? Does it sense our dog is dying?* After a long day of knowing what we had to do, and after a long night of anticipating the dreaded visit to the veterinarian, Monday morning couldn't come soon enough. After the sun rose, we drove our sweet Lola to the vet.

Ever since that eerie afternoon, if I see a raven on my street I wonder about the strange behavior I witnessed that day. Who is this mysterious bird, "ominous" and "beguiling," "grim, ungainly, ghastly, gaunt," as Edgar Allan Poe writes in his renowned poem "The Raven."

Ravens are members of the worldwide family Corvidae (ravens, crows, and jays), and as a group corvids are known to be playful, raucous, and aggressive. They're also damn smart. Why bother working for your food when you can linger at a dumpster or score roadkill? Why let an intruder grab your prized meal when you can mob your competitor, even other corvids, with belligerent chatter and hostile action? This bellicose behavior might explain the collective

title for a flock of ravens—an *unkindness*—and a flock of crows—a *murder*.

We see these big black birds circling high in the sky or hopping around garbage cans and dumpsters. They are not uncommon, but how does one tell the difference between *Corvus corax*, the common raven, and the *Corvus brachyrhynchos*, the American crow? Foremost, ravens are often seen alone or in pairs, crows in large groups. However, vagrant (nonbreeding) ravens roost communally in groups, but typically in smaller assemblages than crows.

The raven is the world's largest songbird, or perching bird (order Passeriformes). Its height ranges from twenty-one to twenty-seven inches, its wingspan, four feet, and it weighs in at approximately three pounds, the size of a red-tailed hawk. The smaller corvid, the crow, is sixteen to twenty inches tall, flies with a shorter three-foot wingspan, and at one and a half pounds is a little larger than a pigeon.

An easy characteristic to distinguish the two is the raven's quasi-beard, more like shaggy throat feathers. Add its thick pronounced beak, and it gets a little easier to tell the two apart. Another identifier highlights their wings. Ravens have deeper indentations (or slots) in their primaries (wing tip fingers)

and sharply pointed wing tips, as opposed to a crow's more rounded, blunt wing tips. Perhaps the most telltale sign is the shape of a raven's tail in flight. From below, it is wedge or V-shaped, as opposed to a crow's squared-off tail.

When flying, ravens soar quietly, often gliding on thermals with slow flaps. They sometimes circle high in the sky like slowly moving objects in a mobile hung above a baby's crib. Conversely, crows don't tend to catch thermals up high; they fly closer to the ground, beating their wings rapidly, flapping and yapping. Ravens fly close as well, and when they do, I easily hear the *whoosh, whoosh, whoosh* of the beat of its strong wings.

When not soaring on wind currents or directly above our heads, ravens might show off their aerial acrobatics with impressive dive bombs. They begin by collapsing their wings, then rolling, diving toward the ground, and finally righting themselves again in a maneuver that looks much like a barrel roll. Sometimes they will repeat this playful act over and over again.

The calls or vocalization of crows and ravens are not as easy to differentiate. The crow calls out its ubiquitous *caw, caw, caw* and rattles, the notes sounding one

directly after another in a quick sequence. Ravens make a similar *caw* but with an added "r": *cronk, cronk, cronk*. They also make clacking, gurgling, and a variety of other sounds used for courtship, aggression, and alarm.

When it comes to food, ravens are all in, eating almost anything in their path. You name it, they've probably eaten it—from bird eggs to young birds (even young sage grouse), small mammals, reptiles, amphibians, large insects, grains, and fruits. Ravens will capture or forage for whatever they encounter that they think they can overwhelm. Its favored meal might be the easy meal, garbage or carrion. (*Carrion* is the dead or decaying flesh of an animal, often roadkill.)

Nevertheless, like other birds and other animals, ravens also cache their food, saving fruit or a dead squirrel for a later time, even hoarding some for winter fare. They do this by placing the food on the ground and then covering it with dirt, grass, or leaf litter. Clever birds, they make fake caches as well to fool nearby birds, even other ravens. With that said, these extremely intelligent birds are *neophobic;* they sometimes fear a food source. When they approach a carcass, they might timidly survey it, retreat, and

survey it again. Even while feeding, they are wary, sometimes flushing or flying off for no apparent reason. But once the meal is determined, ravens aggressively defend their food. If food becomes scarce, breeding ravens are known to "commute" up to thirty miles one way to find their sustenance.

Like most birds, ravens nest in the spring, in March, in high places like trees, cliff faces, telephone poles, or buildings. The female incubates her five to six eggs while the male brings her meals. At three weeks the chicks are born, both parents attending to the *altricial* (needing a lot of parental care) young. At five to six weeks, the young fledge. At two to three years, or sometimes in the first year, juveniles will begin the search for a mate. Ravens can live ten to fifteen years in the wild if not apprehended by predators: golden eagles, great horned owls, and goshawks.

Year-round I enjoy the raucous ravens—along with the mountain chickadees—as my constant neighbors. Quite at home with humans, they squawk, fly high, then low, and hop about on the ground. Maybe out of all the birds I encounter daily, this corvid neighbor of mine reminds me how connected we are to nature . . . like the day our dog died and a raven joined our little wake.

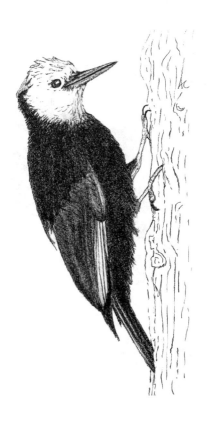

CHAPTER 5

White-headed Woodpecker
(Dryobates albolarvatus)

DURING EACH MORNING as I walk down my street in a sort of wake-up routine, I check the weather and observe who else is out in the early hours of the day. Enjoying my cup of coffee, I listen to the sounds of my avian neighbors. Robins, chickadees, nuthatches, and the one that calls out *tid-it, tid-it, pee-dee-dink, pee-dee-dink*, the white-headed woodpecker, are the first ones to greet me at daybreak. When I arrive at the end of the street, I always look to the top of the largest white fir tree, the one bare at its crown. There, per usual, is the woodpecker's stark white head set against its dark black body. If I have my binoculars close at hand and see a red patch at the back of its head, I know a male white-headed woodpecker is the one making all the noise.

What this woodpecker is most likely doing, as I listen to its short songs and observe it pecking wood, is foraging for food. Hopping up and down the tree

vertically, like a logger with boot spikes, it reaches deep within the bark crevices to gain access to insects and spiders. When finished, the white-headed flies to another tree, flapping and gliding, flapping and gliding, like a dolphin jumping in and out of the water.

One summer, I was lucky enough to find this bird's nest at near eye level, a perfectly circular five-inch hole in an upright seven-foot-tall ponderosa stump. When I approached, a parent stuck out its white head and then flew away, distracting me from its crew of four to five chicks or possibly more, up to ten. What I won't find next year is the same family in the same hole. Next year the nest will be in a new cavity, either in the same tree or in a different one. Next year, the monogamous male and female will be constructing again, and feeding their young, together.

Another summer I walked past a different hole at an even lower level than the previous stump. For a few days, I watched the white-headed enter and exit its nest, most likely feeding a family inside. But, within a week, or perhaps two weeks at most, I noticed a pile of wood shavings splayed on the ground below the stump—evidence that the hole had been greatly widened. A black bear had clawed its way into the nest,

telling another of nature's stories, how one life—or several—is given up for another.

Numerous woodpeckers reside in the Sierra Nevada—the hairy, the pileated, the sapsucker, and many more. But these can be difficult to differentiate because of their similar black-and-white markings and patches of red. Only the female white-headed woodpecker can claim a completely white crown, the only one in North America, its Latin name *albolarvatus* in reference to *albo,* meaning white, and *larva,* meaning mask. In contrast, the male's head, white as well, is distinguished by its bright red patch, a sort of skull cap set just off the top of the back of the head. Another notable mark that distinguishes the white-headed from other woodpeckers is a white vertical stripe painted along the edge of its black outer wing.

As with other members of the Picidae family, woodpeckers have the most unique characteristics, in particular their tails, feet, and tongues.

To begin, how do they climb a tree so easily? Research points to the stiff tail feathers on the white-headed woodpecker that are supported by large muscles, easily bracing the bird as it clings to the tree. In tandem with its *zygodactyl feet*—each foot with two pairs

of toes, two forward-facing and two rear-facing—the tail helps propel the woodpecker up and down tree trunks. Between the tail and the feet, the woodpecker can achieve a steady tripod stance.

The woodpecker's tongue is likely the most unusual of its traits, much like that of a frog in its ability to extend when catching prey. Dissimilar from a frog's tongue, which is attached in the front of the mouth, the woodpecker's tongue is anchored near the nostril or eye. From its anchor, the tongue, like a piece of rope coils around its skull, under its jaw, and out its mouth. When the tongue is extended to capture prey, it acts much like the thrust of a spear gun or harpoon, uncoiling from within and then jutting out at great speed. As well, the tip of the tongue is barbed like a fishhook and sticky with mucus, which helps the woodpecker grab hold of insects deep inside a tree's crevices or on top of pine or fir needles. Between the javelin tongue and spiked tip, insects become an easy meal.

Woodpeckers eat seeds as well by opening cones hanging from ponderosas, Jeffreys, sugar pines, and firs. They especially glean them during the winter when insects become scarcer. In addition,

the white-headed will join other woodpeckers during the summer and fall after fires have destroyed a forest to take advantage of the abundant bark beetle larvae in dead and weakened trees.

Other than pecking into trees for food or to create a nest, the white-headed and other woodpeckers "drum" or peck in a rapid sequence to establish territory or attract a mate. According to one source, a woodpecker will repeatedly bang its beak against a tree with a force ten times that of a concussion-inducing football tackle, which prompts the question: How can woodpeckers jolt their heads with such intensity and not inflict some kind of damage?

It turns out it's all about the structure of their skull, which features thick muscles, sponge-like bones, and a third eyelid that keeps bird brains intact. Directly before a strike comes across the bill, dense muscles in the neck contract, and the bird closes its thick inner eyelid. The eyelid acts like a seat belt, keeping the eye from literally popping out of its head. In other words, nature proves once again that endowed with certain characteristics, a species is equipped with whatever it needs to survive.

I remember the first time I spotted this white-headed

wonder, many years ago. I couldn't believe such a special bird lived where I lived. No other woodpecker in North America has an exclusively white head, yet here it was, and still is, in my neighborhood in the Sierra. It's one of those marvels that surrounds us that we're often unaware of—until we listen a little closer and look a little deeper to find a bird like the white-headed living among us.

Animals

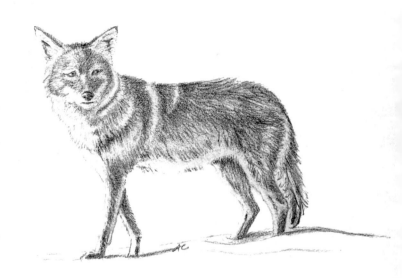

CHAPTER 6

Coyote
(Canis latrans)

> Who besides me could dance with stars, and fall out of the sky for ten long winters, and be flattened out like a deer hide, and live to tell the tale? I am Coyote. I am powerful. I can do anything!
>
> —Richard Erdoes and Alfsonso Ortiz,
> "Coyote Dances with a Star" (Cheyenne),
> in *American Indian Myths and Legends*, 1984

AFTER ONE OF our final nights of deck-sleeping, I wrote in a journal: "Another summer and fall has brought us all sorts of wonderful critters and sky delights: bears, coyotes, raccoons, and deer; the moon, the stars, the morning sun, pines and firs that reach forever high. We will miss the morning chatter of chickadees, jays, crows, and nuthatches. We will miss all of it, in you, the natural night."

In the winter, the creature I miss the most is the coyote. It's not that they aren't still here, because they

are. We hear them from beyond our closed windows, howling for more than an hour, punctuated by an intermittent, solitary high-pitched yip.

But it's not the same as being outside with them, listening to their howls at the edge of the woods at night.

Its scientific name, *Canis latrans*, translates roughly to "dog barker" ("coyote" comes from the Aztec word *coyotl*, "trickster"), which couldn't be a more appropriate name for this doglike howler. With its nose pointed to the sky, it belts out a *yip, yip, eeee-rrrr*, or an actual bark.

It's a bit confusing to listen to coyotes and determine how many of them are singing, the chorus easily distorted as it passes through the environment. Two coyotes can sound like seven or eight. This auditory illusion, known as the *beau geste effect*, tests the listener's ability to detect the precise number that call into the night. Is it one, two, four, six? Once one group of coyotes starts howling, chances are other alpha pairs nearby will respond with chorus after chorus of group yip-howls. *Beta coyotes*—the previous offspring of the alpha pair, plus current-year pups—might join a group or pair too.

Not all howls are easy to differentiate, yet there is a distinction between two types: one, a group yip-howl,

and two, individual howls mixed with barks. The yip-howl promotes family bonding and announces the territory lived in. In other words, the coyotes are saying, *We're a happy family and we own this turf, so you better keep out.* In a sense, the group howls create an auditory fence around a territory, supplemented with physical scent marks (urine).

The other type, the individual howl and bark, indicates that the coyote has spotted a person, a dog, or another large animal that poses a potential threat. Imagine a scenario where a lone coyote is patrolling the territory boundary and comes across an intruder. It will most likely bark and howl, a signal to the mate and beta children to come running.

As for coyote family dynamics, coyotes are *monestrous*—one heat during the breeding season—mating between January and March. Yearlings can breed as well. Two months later, in March to May, three to ten pups are born. Pups are nursed from birth, and at three weeks old their parents feed them regurgitated meat. At five to seven weeks, they are weaned. By fall, at the age of six to nine months, the pups go out on their own. (The average life span of a coyote is ten years.)

Parental involvement is a communal affair. Both parents care for their pups, with help from siblings born the previous year. But sometimes *associates* become part of the pack too, possibly inheriting or displacing members of the breeding pair and becoming alphas themselves.

While residing with their parents, pups benefit from the protection of dens against weather and predators such as the mountain lion. Dens can be made in deep holes, spaces under rock ledges, in hollow logs, or on steep brush-covered slopes; or in existing burrows made by other animals such as raccoons, skunks, marmots, or even bears. They can also incorporate interconnecting tunnels and multiple entrances.

The social system of coyotes is an interesting study. A territorial pair, an alpha male and an alpha female, will defend their two- to fifteen-square-mile area, even from another coyote called a *floater*. Floaters, often solitary, tend to be young, sometimes mangy and inexperienced, who in their boldness will sneak around where two territories meet. The floater does not always remain a loner, however, as it will sometimes replace a part of a pair that has lost its partner.

Coyotes can mostly be witnessed slinking about at the crepuscular times of day, dawn and dusk, most likely on the hunt. Mainly carnivorous, they use those hours to track down rabbits, mice, voles, squirrels, and ground-nesting birds. They'll even take down a full-grown deer since they've been known to clock speeds of over thirty-five miles per hour. When they're not eating animals or birds, coyotes forage for berries on manzanita or coffeeberry bushes. Otherwise, they will consume human garbage and carrion. In other words, they'll eat almost anything.

Bigger than a fox yet smaller than a wolf, the coyote is comparable in size to a medium-breed dog, weighing twenty to forty pounds. But with a closer look, especially through a pair of binoculars, the differences between this dog-like animal and its domestic brethren are straightforward. Coyotes have a bushy tail with a black tip, a long, narrow muzzle, and a flat forehead. Their ears, standing erect, are large in relation to their head, their feet small in relation to their body. Their legs seem longer than those of most dogs because the elbows are located higher. One of the best ways to determine the difference between a coyote and its canine cousin is by looking at their tracks.

First, coyote toes are tighter together than the dog's more splayed toes, the toes pointing forward; thus the coyote's paw is more oval shaped than that of the wider, more circular dog's foot. Trails are another way to tell the difference. Coyote trails are straight and direct because they "direct register"—the hind foot landing on the same side as the front foot that had just landed. This straighter line makes it seem as if the animal has only two feet. Dog trails are more varied as dogs are more easily distracted and lack the exclusive mission to capture prey. Still, with all these clues, it's not obvious which is which.

Known as the trickster in Native American stories, the crafty coyote remains a prevalent species in the Sierra, the one animal that, to me, feels primitive. When I listen to it sing at night, I feel a sense of the past, as if a coyote's archaic howl doesn't quite belong in the modern world. In my body, it resonates the same as a low rumble from a thundercloud or a loud reverberation from boulders crashing down a talus slope.

From this mysterious golden dog, I hear wildness.

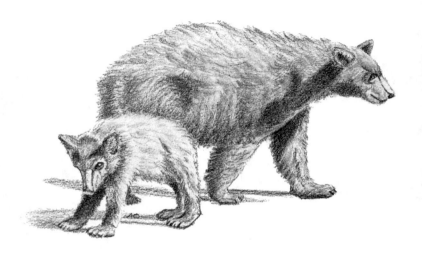

CHAPTER 7

American Black Bear
(Ursus americanus)

EVERY TIME I see a black bear in my yard or street or in the forest near my house, I am in complete awe of its size and the stealthy way it moves. I've rarely spotted these gentle giants on my own. Only if my dog barks or if I turn my head at just the right time do I see this discreet creature.

I will never forget one midday in June when I witnessed a black bear sow and her three cubs wandering onto the empty lot next to us. The cubs, choosing the property as their playground, tumbled and rolled over one another while the mother turned her attention to a ten-foot-tall ponderosa stump. Quickly and with great dexterity—considering her large size—she climbed the relatively short snag with an intense, task-oriented drive.

Toward the top of the stump, a woodpecker hole tempted any passerby to investigate and perhaps welcome itself to a tasty meal. Sure enough, the sow

decided to do just that. Once at the opening, not far off the ground, she clawed repeatedly and so furiously that sawdust erupted into the air. She finished her task within a few minutes, climbing back down and carrying parts of a nest with, I assume, eggs or chicks in her paw. Not long after, a northern flicker flew into the newly widened hole, quickly exited, and perched on top of the snag. It called and called until its mate joined it, both crying out as if to say, "What just happened? Where are our babies?"

Another scene: a mother black bear rests in a ponderosa pine, sleeping so soundly her tongue rests between her teeth. She sits on a branch fifteen feet off the ground, her front legs curled over the branch above her, her six engorged teats drooping low. A good forty-five minutes into her nap, one of the three cubs tussling above her in the crown of the tree climbs down to her level to wake her up. The mother bats at the cub for a quick ten-minute play session but soon resolves to end the exercise. After climbing down the tree that had housed her family for over an hour, she heads into the adjacent undisturbed woods, cubs in tow.

American black bears—also cinnamon brown, light

or dark brown, or blond in color—are common in the Sierra, the biggest mammal here at 150 to 500 pounds. At such a grand size one might think that a cub would be at least 10 to 20 pounds at birth, but in fact a newborn weighs in at a mere 8 ounces, the size of a rat. I've always wondered how such a small bruin can turn into such a substantial adult. Research points to several factors: enriched milk, a variety of foods, a slow metabolism, and torpor.

Before a cub starts eating solid foods in the wild it nurses on rich, fatty milk for its first year. Compared to cows' milk, 3 to 5 percent fat, bears' milk contains 20 to 25 percent fat. Other than their daily milk supply, cubs learn to feed on grasses, tubers, roots, and berries. Protein-rich insects, such as beetles, ants, ground wasps, and insect larvae as well as bird eggs, fish, and small mammals also provide supplementary nutrition.

Still, even with fatty milk and ants and eggs, it seems a mystery how the black bear can grow so large. However, when one considers the lackadaisical nature of this mammal and its sauntering stride, it's not hard to see why it doesn't require the high caloric intake other animals need. Yet, despite its languorous

nature, the black bear is all about consumption. Feeding more fervently in the fall, its main objective is to gain as much as 30 percent of its mass in fat before winter dormancy. Such overeating, or *hyperphagia*, escalates the caloric intake to twenty-thousand-plus calories a day. As one bear professional describes this feeding frenzy: "A bear is a stomach with 4 feet."

For the sow, gaining weight is intrinsically tied to survival and motherhood; pregnancy depends on a significant weight gain. After the mating season, the female feeds all summer and fall. Still, if she doesn't attain sufficient body weight (mostly fat), her embryos may not grow vigorously or even implant.

Of course, we have always been led to believe that if there is any animal in the wild that hibernates in the winter, it's the bear. And black bears do hibernate, sort of. They lower their heart rate while in a semi-hibernation state, also known as *torpor*. Though sluggish during this time, they will still react to danger and move about but then return to their torpid state.

While in this drowsy state, the black bear forms a *fecal plug*, a dense mass of intestinal cells and secretions, hair, feces, and bedding material like mosses. This bundle of matter blocks the gastrointestinal tract

and allows the sleepy bruin to remain in its den for up to six months without eating, hydrating, defecating, or urinating. In this way, the sleepy bear survives off its stored fat while reabsorbing its wastes. By month 6 or 7, it releases the plug (defecates), often near the den's entrance.

Wintering black bears do leave the den on occasion to move about and stretch, but a pregnant female rarely leaves her den, the space having been readied for her cubs. That area, created in large rock crevices, under downed trees, or excavated into softer soils near roots, might be cramped, but it is roomy enough to house the sow and her litter of one to three cubs.

The mother bruin gives birth between January and February when she is around four years old. Subsequent litters might come along every other year. In the spring, the cubs emerge from their cozy den, weighing approximately six pounds, the size of a bowling ball. They continue to feed from their mother through their first summer and sometimes well into their second year. They sometimes even continue to nurse after being taught how to forage in the wild. Such lessons involve tearing at a downed log to glean beetles and larvae, ants and ground wasps. Other

times, they might dig up bulbs or pull at the leaves of mule's ears and skunk cabbage. Some bears can be seen dragging a fish from the edge of a lake. After reaching a secure sixteen months, cubs are pushed out to find a territory of their own.

While it's true that black bears are generally not a danger to us, sows are not as complacent as males. If a female sees an intruder approach her cubs, she might take a few steps forward, at the same time snorting, moaning, or talking with a *ruhr* sound. This is known as a *bluff charge*. Males express these noises as well, while protruding their lower lip. But with all this huffing and puffing, black bears are generally known to be nonconfrontational, at least in the Sierra.

In view of humans' interaction with black bears, it's simple—a bear that becomes accustomed to roaming and/or living in areas of human habitation gets shot. If a bear's memory bank registers unnatural food sources (they can smell food three miles away), it can become habituated to people's food and trash and won't know how to find food on its own in the wild. They quickly learn when it's garbage day and which cans are exposed, where unlocked dumpsters and unlocked cars with food are located. They learn the

location of compost piles and bird feeders. Bears are smart. Being familiar with humans and their accessible food items can lead to a bear's demise.

When we come across this majestic animal in the forests of the Sierra Nevada, we are often caught off guard. Some 150 to 500 hundred pounds or more of bone and muscle and fat and fur, approaches—and we don't even see or hear it coming. Another diorama reveals the *Ursus americanus* and all its habits. Whether it's cubs playing in the crown of a tree or a mama bear providing sustenance for her family, we are privileged to view the cycles of life right here in our backyards, bordering another species' wild home.

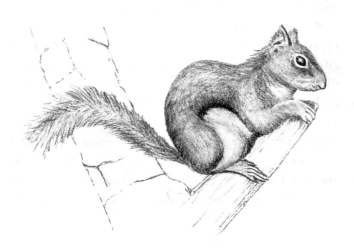

CHAPTER 8

Douglas Squirrel
(Tamiasciurus douglasii)

> The Douglas Squirrel is by far the most interesting and influential of the California Sciuridae [squirrel family], surpassing every other species in force of character, numbers, and extent of range, and in the amount of influence he brings to bear upon the health and distribution of the vast forests he inhabits.
>
> —John Muir, *The Mountains of California*, 1894

THE DOUGLAS SQUIRREL, AKA the chickaree, aka the animal that the *Peterson Field Guide to Mammals of North America* calls "the noisy little squirrel of the evergreen forests of the West," is one of the most ubiquitous creatures in the Sierra Nevada. We see them scurrying around our homes and in the forest, climbing up and down pines and firs, calling out loudly and rapidly *chick, chick, chick, chick* or *quer-o, quer-o*. With a twitch of its tail, it chatters madly at territorial

offenders—bobcats, coyotes, owls, and sometimes us—for invading its space.

In my neighborhood at six thousand feet in the Sierra, I observe both the chickaree and the larger squirrel, the western gray, running up and down pines and firs, sometimes youngsters chasing one another in play. But how does one tell the difference between our most common squirrel residents, the Douglas, aka chickaree, and the western gray squirrel? Fortunately, they're easy to distinguish.

The chickaree's black racing stripe along its sides is a dead giveaway. Although the line fades in winter, the division of the reddish-gray upper body from the pale-yellow underbelly is easily spotted in the summer. Also conspicuous is its black tail, the edges painted in a frosty silver. In contrast, the gray's bushy tail, sometimes puffed out as if triggered by static electricity, is its easiest identifier. Squirrel tails, overall, are extremely useful, providing balance as the animals leap from branch to branch, warmth during the colder months, and a way to communicate with other squirrels and animals.

When it's time to hunker down and build a nest, chickarees search for an old woodpecker hole or build

a *drey*, a birdlike nest but globular, with enclosed walls and a roof, twigs placed on the outside, grasses and lichen lining the inside. Six weeks in, a brood of up to five kits, also known as pups, is born. Within an additional six to eight weeks, the kits explore their territory; another two, and they're on their own.

Considering squirrels as squirrels, one might guess that chickarees favor pine cone seeds, and in fact they do. I've been bombarded by the cones they unleash, especially if a heavy immature green one drops to the ground; I best get out of the way.

For chickarees, the feat of detaching the cone from a branch—to glean its seeds—is possible because of sharp incisors that cut the cone at its base. How handy to have a sharp instrument in one's mouth! But there is another reason a chickaree must keep vigilant in its cone cutting. Its incisors continue to grow in adulthood, curving inward as the squirrel matures. If the teeth aren't continually filed down, *malocclusion* occurs, an abnormality in teeth alignment that can prohibit this seed-loving collector from snipping scales from cones and eating its seed meal.

Once the cone is detached, the chickaree either lets it fall naturally to the ground or flicks it in the air

with a jerk of its head. After the pine cone lands, it has two choices: dig in or add the cone to its winter storage unit. Either way, seeds provide a nice layer of fat, being high in oil, protein, and carbohydrates. Remnants of this feeding frenzy are easily seen by cone cores littering a forest floor or strewn across the tops of fallen trees.

Other favored foods include berries, mushrooms dried in the sun, flowers, the tips of pine and fir branches, and bird eggs.

If a chickaree chooses to store its fare, since it doesn't hibernate, it can preserve pine cones in a version of a winter pantry called *middens*. Middens contain piles of pine cones—dense, heavy green ones, which remain in the ground longer, like a ripening avocado, and/or mature brown cones. Chickarees stash these reserves next to rocks or logs close to their home tree, and often near a tree well, the area around the trunk of a tree that receives less snow. Underneath the midden, a *subnivean* layer forms between the ground and the snow directly above it, the soil containing heat. This empty space, a one- to two-inch gap, provides a place for the chickaree to burrow and find its middens in the winter.

One last thing on middens: think of them as insulated coolers. Because they're covered with leaves, dirt, and harvested scales—the perfect decomposing debris—and cold, damp earth, the cones are well preserved and protected from drying out or opening.

While tree squirrels might seem extra industrious one year, the busy activity doesn't necessarily mean an impending big winter. It's more likely that the squirrels are reacting to a big cone crop year rather than predicting what's to come; they're capitalizing on the supply and caching as much as they can, both for the present year and the following one. The same question could be asked of the pine and firs themselves: does an abundant year of cones predict a heavy winter? Pine cones take two years to develop, so if there are a lot of pine cones on the trees we know the pines have had two seasons of good climate.

Whether the chickaree is stashing cones in middens or eating them on the spot, its habits of spreading seeds, thus establishing tree seedlings, makes it a kind of Johnny Appleseed. As John Muir says of this industrious *Tamiasciurus*, "Nature has made him master forester and committed most of her coniferous crops to his paws."

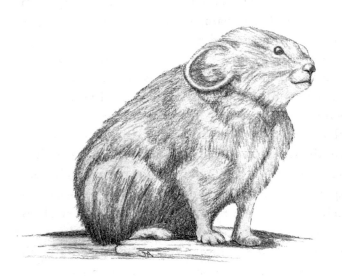

CHAPTER 9

American Pika
(Ochotona princeps)

TALUS FIELDS, ROCK piles accumulating at the base of steep slopes, are found regularly in the high country. Standing below one of these often-enormous mountains of boulders, makes me feel small but at the same time connected to the wild. Granite speaks to me in a way that's hard to explain. The multiple shades of gray, speckled with black dots and sparkling mica flecks, define, for me, the Sierra Nevada. There's just something about hopping from one boulder to the next, something about rock and boot, a connection between the cold, hard granite and my feet carrying me over the terrain.

Within those rock piles is found one adorable little creature—the pika. "Cute" is often written in its description because who wouldn't be attracted to this little mouse-like animal? The size of an avocado, about six inches long, it weighs four to seven ounces (similar to some hamsters) and has round protruding ears. It crouches on top of boulders in the talus,

seemingly curled up in its spherical self, and calls out a high-pitched squeak. If a person didn't know it, one would think a noisy gray and brown hamster had escaped into the wild.

The first pika I encountered was during the one summer I worked in the backcountry in the Hoover Wilderness near Bridgeport, California. At around nine thousand to ten thousand feet, I would see one surface from a small cavity under the talus, gathering vegetation to eat or store for its winter cupboard. I'd hear it, too, uttering its loud *eek, eek, eek*, certain I was listening to a much bigger animal. I looked forward, each week, to turning a particular bend on the trail to come upon my mountain neighbor, perched on top of a big rock, grass stems sticking out from the sides of its mouth. It was, indeed, cute.

Ochotona princeps is a small mammal, related to rabbits. In fact, the pika is classified in the rabbit family, the smallest in the order Lagomorpha, which consists of two branches: Leporidae, rabbits and hares, and Ochotonidae, the pikas. One defining difference between the pika and its rabbit brethren lies in the pika's lack of big hind legs, which aid rabbits on the run. However, the pika is still quick, dashing across

and in and out of rock piles, evading its predators—long-tailed and short-tailed weasels, and raptors.

We rarely see them or traces of their furry soles that help them gain traction; we do not see their hidden tails. When we *do* see one, its nose pointed up to the sky, calling from the edge of a boulder, we know we've been awarded a special glimpse of mountain wildlife.

Pikas hang out in talus fields all year and actually prefer cold weather because of their thick coat of fur, high metabolic rate, and high core body temperature. Perhaps this is one reason they don't hibernate. To endure the heat of the summer, pikas molt, giving them a splotchy kind of look. Also, to combat rising temperatures, they hide in the talus environment, which provides a unique kind of ventilation. While rock surfaces get hot like pavement, hunkering down in the rocks below the talus surface is like entering a dark cool cave.

The most well-known element concerning these rock inhabitants is their winter food source. Remaining hidden in snow tunnels under the talus all winter long, they depend on *haypiles*, stacks of vegetation gathered and tucked under large boulders in the middle of their territory.

Haypiles are like eateries. They consist of a wide variety of herbaceous vegetation—willows and grasses—gleaned in fore fields in the summer, areas a mere ten to twelve feet from a talus field. Only the leaves of vegetation are consumed, no fruits or flowers or stems. Once a portion of a plant is cut and in the pika's mouth, it carries its prized meal to an already stacked pile, set at the entrance of a hole in front of a boulder. When not collecting grass or leaves of herbs, they guard and defend their haypile. Pine and fir needles are eaten as well, and sagebrush too. Sagebrush is known to be toxic, but after being stored in a haypile for three months the bush loses its toxicity.

During the day, pikas cruise their talus territory, approximately one hundred feet across, eating on the spot until mid- to late summer and into fall, when they begin collecting again. In winter, they graze on their stashed haypiles, emerging in the spring to forage for vegetation once again as the edges of a talus field melts. At this time, as with many Sierra animals, the breeding season begins.

Breeding opportunities can occur two times a year for *Ochotona princeps*, but if the first litter is a success it won't breed again. One to three babies are born

in the spring in the upper part of the talus territory where the mother visits—yes, only visits, as the female sets her nest away from the central haypile, anywhere from twenty-five to fifty feet. The mother feeds her brood a mere once a day, her milk being highly nutritious. There is no involvement by the male.

One month later, the young surface aboveground and set off on their own. Truly, on their own. Juveniles are only "tolerated" by their parents as the young hang out at the edges of their home territory for a few months in the summer after they're born. Other nonrelative adults aren't any more welcoming and can even be highly aggressive to the youngsters. By autumn, the juveniles attempt to find an unoccupied territory in the *natal talus*, the talus in which they were born.

The new lodging that the young search for is often a former resident's, the inhabitant having either been preyed upon, or, because a pika's lifespan span is only three to four years, had lived its full lifetime. If there is no home to occupy, the young ones must move to another talus, but once again, it could be met by aggressive adults.

Hardy little rabbit-like mammals given barely any

parental care, exposed to predators, and faced with harsh climate conditions, pikas live a risky life. But, with a wide piece of territory, an elevation span of approximately six thousand feet, they have room to roam and shelter to protect them.

Talus is the pika's domain. Talus is home.

Plants

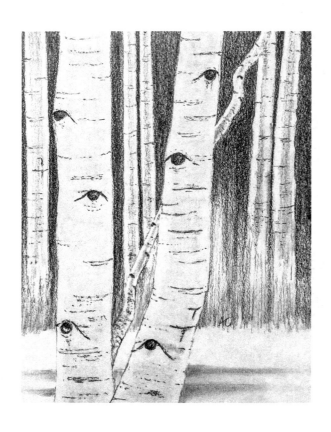

CHAPTER 10

Quaking Aspen
(Populus tremuloides)

IF EVER A tree was aptly named, it is *Populus tremuloides*, whose leaves "tremble" in even the gentlest of breezes. An entire grove of trembling or quaking aspen can sound like rain hitting pavement. But it's not a symphony of raindrops one hears, rather the heart-shaped leaves, tapping against one another, create the *clack, clack, clack* of an aspen song.

In the fall, people make it a point to visit large aspen groves in anticipation of catching the fall colors just right, the shamrock-green leaves having turned a bright yellow-gold, sometimes orange-red. Drive over Conway Summit near Mono Lake, take a hike to Marlette Lake from Spooner Lake at the junction of highways 28 and 50, or simply walk in neighborhoods around Lake Tahoe, and you are treated to a dazzling deciduous display. If you're not in the Sierra Nevada, you can easily spot a spectacle of *tremuloides* in other areas; the aspen is *the most* widely distributed tree in North America.

Stands of this wide-ranging tree ribbon for miles, bright green or yellow or orange forests filling up canyons and ravines, sometimes flatlands. Whether in the Sierra or in the mountains or flatlands of Colorado or Utah, a trail laden with aspen groves is one of the most beautiful sights in nature.

An explanation for the trembling or fluttering leaves points to the flattened petiole, the stalk that attaches leaf to stem. A flattened petiole allows the stem to twist back and forth in the wind, creating an opening for sunlight to enter a stand of trees, thereby aiding in photosynthesis.

Aspens' claim to fame is their ability to clone themselves, sometimes producing one stand in a small area, sometimes a stand that reaches for miles. When cloning asexually, they grow from a fragment of a parent plant, a process called vegetative reproduction. Long roots radiate underground and then rise to the surface to become copies of the parent clone, each "tree" known as an individual *ramet* within the greater clonal colony *genet*. The grove, in this way, represents a forest of identical vertical branches.

The largest clone of aspen, the Pando, Latin for "I spread," resides on 106 acres in the Fishlake National

Forest in Utah. Pando is a single organism, one root system connecting the approximate forty-seven thousand "trees." It has been said that this widespread forest is the largest living organism, by dry-weight mass, in the world.

Other than cloning, this deciduous tree can also produce sexually (albeit rarely), by way of tiny brown male and female flowers within *catkins*—narrow cylindrical clusters that look like fuzzy caterpillars. Aspens are *dioecious*, meaning separate male and female trees participate in procreation (one tree is either all female or all male). When I see one- to three-inch-long narrow cylindrical red-pink flower clusters before the leaf buds break—these fuzzy caterpillar-like flowers known as *pollen catkins*—I am witnessing the beginnings of reproduction from a male tree. Female aspens produce catkins too, but only the male catkin contains pollen to fertilize the female. In the end, if I find myself caught in what seems like a snowstorm of fluffy downy seeds, like those of a poplar or willow, I know I could be standing in the middle of a fertilized seed dispersal. Within fourteen to twenty-one days and under just the right conditions—moist, bare soil and plenty of sunlight with

mild temperatures—procreation prevails. A recently burned forest with some moisture provides the perfect environment to stimulate such germination.

While aspen groves delight many a hiker (there is a certain magic to walking through a forest of tall, white-barked timber with dancing lime-colored leaves), I have entered groves of them sick with disease. Thick black lines that circle trunks and branches indicate that all is not well in the aspen world. Arborists call these strange black marks *cankers*, a disease caused by mechanical injuries or by plant pathogens, especially from fungi or bacteria. When a canker disease kills the bark, a band is made around the tree from the removal of the bark; this is known as *girdling*. Aspen cankers include sooty-bark canker, cryptosphaeria canker, black canker, and cytospora canker.

I have likewise seen "eyes" on these trees with gray-white bark and wondered if the brown to black oval eye-shaped knots, seemingly outlined in heavy black eyeliner, like the dark canker bands, also tell a story of sickness or death. On the contrary, the eyes are remnants of an aspen's self-pruning. As the tree grows taller and reaches for the sun, the lower branches become shaded. The tree, in response, cuts off the

flow of sap, causing the lower branches to weaken and fall. The place where the branch was attached to the tree later becomes the eye.

Another mark widely seen on aspen trunks is caused by beavers. Because aspens in the Sierra are at home in meadows and along streams—also in gravel slopes and bases of lava jumbles—their location suits dam building perfectly. To fell one, beavers cut the base with their long, sharp upper and lower incisors. However, the marks that circle the bark appear more like an ax's work than an industrious beaver's. Aside from dam material, aspens provide beavers with some of their favorite foods, aspen leaves and aspen bark.

Some of my fondest memories of hiking in the Sierra involve aspens and their groves. I've lingered in them for hours, watching each leaf dangle by its thin petiole, twisting and turning, talking in the wind. The yellow, red, and orange path they create underfoot becomes a natural watercolor masterpiece, while the white bark eyes follow me as I walk on its carpet. How amazing is it that one tree, one root, can extend to produce so many miles of color?

CHAPTER II

White Fir (Abies concolor) and Red Fir (Abies magnifica)

LIKE THISTLES, LIKE woolly mullein, or like scotch broom, fir trees, standing tall and proud in many a Sierra Nevada forest, have been thought lesser flora—in fact, considered weeds—even as they look like they belong. Those nasty weeds, if they must be called such, are ubiquitous in the Sierra and in the Lake Tahoe region. Because white and red firs are shade-tolerant, they establish and prosper in shady conditions in the forest understory, giving them the advantage over pine trees, which prefer a sunny environment.

But is a fir truly a weed?

First, to a definition. A weed is a wild plant growing where it is not wanted and in competition with cultivated plants. A weed is not necessarily a plant that is not native; instead, it's devalued because of its dominance, its tendency to take over, its reputation as a stiff competitor with other plants.

California white fir is such a "weed," its tarnished

reputation stemming primarily from the subject of fire. If fires don't regularly occur or if fire management keeps fires at bay, the tree can take over a forest (being that stiff competitor), which can attract pests and diseases.

So the beetles come, sometimes in droves, sometimes turning an entire forest from green to brown. The fir engraver beetle (*Scolytus ventralis*), better known as one of the bark beetles, causes high mortality in white fir stands.

With fire, fir stands are thinned, leaving them less susceptible to disease and insect infiltration. With soft wood, thin bark, and lower branches providing an easy ladder for flames to climb, white fir is the perfect candidate to be consumed by fire. Red fir, is not as vulnerable to fire because its trunk is stouter and its bark thicker.

Identifying which is which, white or red fir, can be somewhat tricky, but elevation, needle shape, and bark color provide simple clues. Elevation, of course, is a good place to start. Above six thousand feet, it's most likely a red fir forest, below six thousand feet, a white fir forest. Firs at the margin or below can be either.

The best way to distinguish white from red is to

look at their needles, much shorter than pine needles. If the mature needles are flat with two white lines on their undersides and come out from the branch at a perfect right angle, the tree is a white fir. If the needles are four-sided, easy to roll between fingertips, and have a hockey stick–like curve where they attach to the branch, it's a red fir.

Fir needles are also edible! The new-growth needles, bright fluorescent green and soft and rubbery at the end of a branch, taste of citrusy lime. I learned this edible plant fact from a naturalist a long time ago, and ever since I can be found chewing the branch tips along the trail.

Another difference resides in the branches. White fir branches extend laterally as flat sprays. Red fir branches curve downward, then up at the ends.

While the needles on a fir are an easy identifier, the bark isn't as straightforward. But color helps. The long, vertical plates deeply *furrowed* (deep grooves) on the white fir tend to be more white-gray, whereas the red fir's are a dark red-brown. Much easier to discern are the colors underneath the outer bark. Simply pull off a small chunk of bark and the white fir reveals a yellow-orange, the red fir a deep reddish-purple.

Additionally, fir cones are unique in their stance on a tree. Unlike most cones, which are *pendant* (hanging down), fir cones (female) stand upright on the topmost branches. These unique cones look like barrel-shaped ostrich eggs or owls perched on a branch. White fir cones are about the size of a fist, three to five inches; red firs' are larger at approximately eight inches. In my eyes, a pine cone, a fir cone—any cone—is one of the most beautiful objects in the forest. How many times have I seen a child carrying one like a prized big brown egg, or baskets filled with them next to a fireplace, purely for aesthetic charm? I've witnessed a stand of firs, their erect cones backlit by the sun, appearing much like Christmas lights, bright and sparkling, at the top of a Christmas tree.

Since the white fir is the chief tree in my neighborhood, I have grown to admire its perfectly symmetrical and horizontal-layered branches, which serve a variety of birds and mammals. Every spring and summer I look for the densely grouped, raisin-sized male cones, hanging down mid-tree. In the fall, I look for the female cones, growing upright in the uppermost crown.

So, why are female cones located at the top of

conifers while the male pollen cones grow a bit farther down? Simple: cross-pollination. The pollen from cones lower in one tree can be blown across and upward into the receptive female cones of another tree. Later in the year, when the female cones open and disintegrate, the pollinated and developed seeds—connected to papery wing-like structures—disseminate in the wind. All that remains of the female cone is a central twig or "candle" that once held the scales and seeds. Subsequently, seeds that fall to the ground and are uneaten by birds and wildlife overwinter in or under the snow. Following snowmelt, the seeds (some seeds) will germinate in the spring.

And the process starts anew, every two to five years.

We see pine cones all the time, but how often do we pick them up and examine them? A pine cone is a mathematical model! Each row of scales is set just a little off from the next so that the cone resembles a pyramidal shape, wider at the bottom, narrowing toward the top, like an artichoke or pineapple. In my mind, these cones encapsulate the natural world in its rugged and wild state. They contain generations of lifetimes, from seed to tree to cone to seed. With a pine cone, we can hold the past, the present, and the future within our hands.

CHAPTER 12

Woodland Pinedrops (Pterospora andromedea)

WHEN ONE THINKS of wildflowers, what usually comes to mind are meadows filled with hip-high yellows, reds, purples, and blues. Color, lots of color, the impetus to hit the trails in spring and summer when the word is out: "They're here!"

But when you're walking or hiking along a forest path and you spot a knee-high brown plant, you might think, *What is that? It certainly couldn't be a wildflower.* Yet this gothic-looking phenomenon, a dark brown stick with "bells" dangling from it, is indeed a flower of the wild.

Woodland pinedrops emerges between June and August, and from a distance resembles a tall stand of asparagus, or, on closer examination, that handheld percussion instrument circled with sleigh bells. If I stoop down, eye to eye with the tall plant, the five-lobed bell flowers appear like papery, brick-red pumpkin lanterns. Underneath each pumpkin,

another artistic design is inscribed: a five-pronged starfish or sand dollar pattern. Other descriptions liken the dull yellow to pink to dark brown flowers (brown in the fall and winter) to upside-down urns. Other than the flowers on the top half, the bottom half of pinedrops is covered with thin curly bracts, the reddish stem, hairy and sticky.

What's interesting about this one-of-a-kind plant is how it grows, feeds, and reproduces. And how, by some, it has been called a "freeloader."

Green plants have chlorophyll, which allow them to photosynthesize their own food from sunlight, water, and carbon dioxide. Pinedrops *lacks* chlorophyll, so it doesn't take on the green pigment, like that of the snow plant (*Sarcodes sanguinea*), a relative of pinedrops also in the Ericaceae family. Nor can it produce its own food. Instead, pinedrops capitalizes on the relationship between pine trees and fungi—thus the association to being a freeloader.

Cone-bearing trees, also known as *conifers*, exchange photosynthesized organic compounds for soil, minerals, and water provided by the fungus through a network of fungal threads that encase the tree's root hairs. This is a mutually beneficial symbiosis. Pinedrops,

on the other hand, has a connection between its own roots and the fungus, theirs roots extracting from the fungus—some of the organic compounds originally produced by the pine. I think of it as a line: tree, fungus, pinedrops. Pinedrops receives the necessary sugars from the photosynthetic work of neighboring plants through a fungus bridge. This relationship is known as *mycotrophic*.

Another unique characteristic is its roots. The tall year-round plant emerges from the earth from a tight ball of *mycorrhizae* (connection of fungus with roots), about a quarter of an inch in size. Some of the roots elongate, producing other root balls, which explains why several plants can be found growing in the same area, and why a few plants are often seen attached to one another with a multi-headed (two to three or four to five) upright branch.

Once out of the ground and onto the ground, pinedrops thrives on the forest floor in *forest duff* (partly decayed organic matter), maturing in only one summer season, but sticking around all fall and winter, sometimes for several years (a perennial, the plant grows for more than two years).

Concerning reproduction, another unique element

is involved: the seed under a microscope looks like a peppercorn and a sail. A magnified version of a pinedrops seed reveals a red peppercorn or red pinhead with a clear Saran Wrap triangular sail attached, five times as large as the seed. Its genus name, *Pterospora*, means "wing-seed" in Greek. This sail-wing apparatus permits the seed to be blown and cast out long distances on a windy day, thus contributing to the broad distribution of this persistent plant.

The bell-shaped flowers/capsules are produced in about four weeks, typically in June. Fruiting usually occurs in late July and August. After fertilization, the capsule requires two to three weeks to mature. Depending upon the size of the plant, from 20 to 128 fruiting capsules (flowers) are produced, each bearing from 2,000 to 4,800 short-lived (three to nine weeks), wind-dispersed seeds.

Out in the pine and fir forest around my house and in the nearby undeveloped woods, I look for pinedrops like I'm playing a game of camouflage "I Spy." The predominantly brown stalk hides well in the earth-colored forest duff except for its erect stance. Persistent pinedrops, the moniker I bestowed upon it a long time ago, always reminds me that I am

guaranteed to see this hardy plant not only in spring alongside its more flamboyant neighbors, purple penstemon and white Mariposa lilies, but also in winter, peeking over a snowbank. This is what I love about this camouflaged "greenery." Not all mountain wildflowers shine bright in reds, yellows, and blues. I delight in knowing I might spot a "wildflower," albeit a brown one, poking through the snow.

CHAPTER 13

Needle Drop

"Is that tree dying?" you might ask. Around the base of the tree, you see hundreds of brown pine needles circling the trunk, like a Christmas tree skirt. Surely the tree is dying, you think; it's on its way out. But what you see might not be death at all. The tree is most likely shedding its needles as part of a normal life cycle.

Needle fall, also known as *needle drop*, is a natural phenomenon that occurs in the autumn. Just as we shed our skin, our fingernails, and our hair, pines and firs shed their body parts too. The process begins in the spring as new needles grow at the tips of branches, showing a much lighter green than the older needles. With new growth, the older, inner needles become shaded, hindering photosynthesis, making them no longer suitable contributors to the tree's growth. In the fall, those older needles turn yellow, orange, or brown, and then, in the coming weeks, they die and drop to the ground. Out with the old, in with the new.

It's an unlikely occurrence, we might suppose, as

we consider evergreens to be, well, ever green. But for a tree to continue to grow, the inner needles need to be replaced by new ones. Death and birth. Three-year-old needles fall, and the two-year-old needles remain until the following year, at which time they fall, and so on. Shedding is a continual process in a regular life cycle. Nothing lives forever.

To understand this relationship between a pine needle and a tree, it's imperative to first understand the structure of a needle. Needles can be likened to multiple pipes fused together into vascular bundles. Water and minerals flow up through one type of pipe in the pine needle, enter soft green cells and little clusters of chlorophyll, and undergo photosynthesis with sunlight. With the newly made nutrients, sugars flow into the other pipes to feed the tree's needles, wood, and roots. But as a sheath of new tissue is formed and grows outward, branches with the older needles are *girdled* (stripped), eventually breaking connection with the tree and thereby ending the older needle's ability to absorb water and minerals. Those needles then turn color and fall.

Likewise, pine needles have a narrow and waxy surface, which helps them bear a dry climate. The

narrow form reduces the surface area exposed to dehydration. The waxy coating, known as the *cuticle*, outside the thick epidermis, provides a barrier to water loss. Additionally, pine needles "breathe" because of pores called *stomata*—openings in the needles that allow for gas exchange and water runoff. The stomata, aligned in rows on the surface of the needle, appear as very thin white lines. Breathing needles, breathing life!

Until they're not.

Again, inner needles die when choked off from sun and nourishment. The death of the needle, *apoptosis* (death of cells), is just part of a tree's natural development, or, as has been quoted: "It's programmed death. Pines shed about a quarter of their green needles." Overall, firs shed after ten years, spruce after six, and pines after three.

Needle fall takes place in September, October, and November in all conifers, which for portions of the Sierra include ponderosa pine, Jeffrey pine, lodgepole pine, sugar pine, white fir, and red fir.

With all that said, needle drop is not always the cause of dead needles. If an entire branch, or even an entire tree, is covered with dead or dying needles,

other causes could be attributed, linked to drought, disease, insect infestation, or injured roots. Any number of impairments can contribute to a tree's demise.

During a windy day, it can seem like the sky is unleashing a rainstorm of pine and fir needles. One can hear the needles scratching at the windows or feel them pelting one's back. The forest floor becomes covered with a layer of needles, sometimes as thick as a soft, plush carpet. Needle fall tells us . . . life ends, life begins, and winter is on its way.

Mushroom, Algae, Rock, Arachnid

CHAPTER 14

Shaggy Mane Mushroom (Coprinus comatus)

BEFORE WE WOKE up to a foot of snow one October, a tenacious mushroom pushed its way through duff and dirt, wood chips, and hard-packed ground. The shaggy mane mushroom, also known as the lawyer's wig (like a British barrister wears), appears in late summer and fall, like soldiers lined up in a row or football players crowded together in a huddle. Sometimes, but rarely, they occur singly. The shaggy mane persists in emerging, no matter how hard the surface, to show off its brown curls on its smooth ivory surface.

Mushrooms, overall, can be difficult to identify because of lookalikes, but the shaggy mane is one of the easier mushrooms to name. The up-curled scales on the elongated bullet-shaped cap (up to six inches long and two inches wide) are its most definitive identifier, as if a woodworker had taken a small chisel and carved upturned tan and brown hairs: *comatus* in Latin, meaning hairy.

The bell or bullet shape of the young cap, or *pileus*, covers most of the smooth, perfectly cylindrical and chunky stem. The stem, or *stipe*, is hollow, wider at the bottom, narrowing to where it attaches under the cap. The *gills*, accordion-like, paper-thin ribs under the mushroom cap where the spores are held, are set extremely close together.

The shaggy mane appears most often after rain, so this is the best time to look for them. At first, the tops reveal themselves aboveground, with dirt tossed to the side as if a dog had been digging for a bone. Within a day or two of being fully exposed, the slender popsicle-shaped mushrooms dissolve into dripping umbrellas and finally a black inky puddle.

To fully understand this liquefying process and the release of spores, *autodeliquescence* must be discussed, translated literally to "self-dissolving."

In contrast to many other gilled mushroom species, whose spores fall between the gills and into the wind, in the shaggy manes, the mature black spores are released from the margin of the gills and into the wind. This course continues from the lower margin of the cap to the top of the stipe.

The gills liquefy from the bottom up as the spores

mature. As the cap peels away, the maturing spores are in the best position for catching wind currents. As this happens, the shape of the cap progresses from that of a bell to a flatter form. In other words, as the bottom of the cap dissolves, more of the stem is exposed, like an umbrella. An umbrella is cylindrical at first, but as it's opened the shaft becomes more exposed. When fully opened, the shaft is completely visible and the umbrella canopy is flat.

The self-digestion continues until the entire body turns inky black. Many describe this process as "melting into black goo." Some people call this sticky liquid, ink, and in fact the viscous substance can be used for writing or dying paper, wool, and fabric. If you touch the ink, it will stick to your finger, as if you've pressed your finger on an ink pad.

Like so many parts of nature, the shaggy mane plays a significant ecological role, its part to be a recycler. When aboveground, the spores are dispersed, while at the same time the mushroom's organic nutrients dissolve back into the soil. A *saprobic fungus*, the shaggy mane releases enzymes to break down the organic matter into simple soluble compounds that can be absorbed by plants as nutrients. From life to death,

the shaggy mane supplies nourishment back to the earth.

While the tar-like substance of this evolving mushroom may not seem appetizing, this fungus is considered a delectable species when it is beginning to emerge. Of course, the fact that shaggy manes often sprout from dung—*coprinus* means "dung" in Greek—might deter the desire to whip up a pan of them. But, sautéed in butter with chopped onions, salt, and pepper, and added to soup or pasta, they make an enjoyable special wild treat. They must be picked while they're still white and young, before they turn black, and prepared soon after being harvested. Most important, check with a mycologist, a fungi expert, before picking and eating any wild mushroom. Many are toxic, and some are fatal.

CHAPTER 15

Watermelon Snow Algae (Chlamydomonas nivalis)

LONG AGO, OFF the northwest coast of Greenland, Captain John Ross, on an exploratory voyage from England, noticed snow streaked with red. According to an article in the *London Times* on December 4, 1818, "Sir John Ross did not see any red snow fall; but he saw large tracts overspread with it. The colour of the fields of snow was not uniform; but, on the contrary, there were patches or streaks more or less red, and of various depths of tint. The liquor, or dissolved snow, is of so dark a red as to resemble red port wine." At first the snow was believed to be enriched with iron; it was not until the end of the nineteenth century that this unusual phenomenon was recognized as an algal bloom.

A variety of pink and red associations comes to mind when one looks at a field of snow tinted in blood red or cotton-candy pink. Strawberries. Blood. Port wine. Watermelon.

I remember the first time I crossed a patch of it high above Bridgeport, California along the Eastern Sierra. The large snowfields, splattered with splotches of pink and streaked with red lines, were nothing like I had ever seen. Midway up the traverse, I stopped on the trail to take in the curious scene, wondering what could have caused such a deep pigment. As a hiker was just about to pass I asked him, "Do you know why this snow hill is red?"

He kneeled to the ground, lowered his head to the snow, and took a big whiff. "This is watermelon snow. It's a kind of algae. If you get right up to it, you'll notice it smells just like watermelon." I took off my pack, sniffed the pink stuff, and wouldn't you know it, the scent was just like that of the sweet fruit that dribbles down our chins on the Fourth of July.

So, what causes snow to bear a resemblance to watermelon? The answer? *Chlamydomonas nivalis*, green, freshwater algae. These algae possess a red outer layer imbedded with pigments called *carotenoids* that help this single-celled organism absorb just enough light for photosynthesis.

Chlamydomonas nivalis, or *C. nivalis* for short, is a member of the green algae family Chlorophyta, but

unlike most species of freshwater algae, snow algae are *cryophilic*, cold-loving, and thrive in near-freezing water. Its scientific Latin name, *nivalis*, refers to snow, snowy, snow-like, or snow-covered. Nevertheless, the magic transformation to watermelon snow occurs not when it's cold, but rather when it's warm, in the spring or early summer when the snow begins to melt. During this period, algae make their way upward to the snow's surface to bask in the sunshine.

How each stage of the life cycle of snow algae works is hypothetical, as it's difficult to see every phase as it is happening. But there is a hypothesis, and it goes like this.

A previous year's snow algae lie dormant on rock or under shallow snow, as thick-walled and nearly impenetrable cysts, until spring and summer. The snowmelt, rich with nutrients from a dusting of pollen and organic debris, trickles down through the snow. At this point, the dormant cysts awaken and germinate and begin to proliferate. This process is often referred to as an *algal bloom*.

Reproduction of the awakened algae takes two forms. One, algae cells multiply by simple cell division, essentially duplicating or cloning themselves.

The second way is by fusion, like gametes, or sperm and egg. They do this as the algae grow thread-like "flippers," properly known as *flagella*. The two flagella enable the cells to swim toward a partner. When they meet, they entangle and fuse. As is the case with so many other species, a new generation results, this time with two sets of chromosomes. The flagella also assist the algae in swimming upward to or very near the surface of the snow to gain precious light for photosynthesis.

Approaching the surface, the algae change from green to orange and finally red, using increasing levels of carotenoids to protect themselves from harsh direct sunlight. Always underneath the red pigment, however, lies the green pigment.

Once the algae perceive light, they shed their flagella, no longer needing mobility, and use their chlorophyll to make sugars in the process of photosynthesis.

All algae need sunlight for photosynthesis, yet high-altitude sun with lots of UV in areas where snow algae reside is destructive to the cells; it destroys DNA. To protect itself from such intense sun, the red carotenoids suppress the ultraviolet rays, enabling survival

in the "hot zone." These red pigments in *C. nivalis* are accurately likened to sunscreen or sunglasses.

Conversely, the darker red and orange pigments of the algae absorb and transfer warming wavelengths to nearby snow crystals, causing them to melt, providing the algae with water for photosynthesis, but also water infused with nutrients. Nutrients come from the melting snow permeated with pollen or organic matter—needles and insects—blown from nearby subalpine trees and shrubs. Scholars of artic-alpine ecosystems refer to sources of such air-transported nutrients that nourish microorganisms on the surface of the snow as *aeolian* (windblown).

At season's end, after the snow completely melts, *C. nivalis* remain in the warm soil in cyst form, until winter arrives and the cycle begins again.

Algae might seem too small an organism to offer any substance to what surrounds it, but algae are first in line to provide food for small invertebrates like tardigrades and springtails. Subsequently, tardigrades and springtails become food for larger organisms like mites, spiders, and even small birds. While we might not be able to observe these stages of watermelon snow, it's quite something just knowing that

such tiny algae are hard at work painting red and pink designs. Red on white, streaks and spots. Such designs in the art world are known as "splatter or action paintings." But here in the mountains, nature creates her own art and on her own canvas.

One word of caution: while watermelon snow might smell sweet and be tempting to eat, especially after a long ski, snowboard, or hike, sipping large quantities has been known in some cases to cause digestive ailments.

CHAPTER 16

Glacial Erratic

HAVE YOU EVER been walking through the woods when you suddenly come upon a colossal rock sitting all alone, a boulder the size of a Subaru or Tesla—or bigger? Some such boulders can be as big as a tiny house or an upended train car, which raises the question: How on earth did such mammoth rocks, so seemingly out-of-place, end up where they are?

The answer? They hitched a ride.

It's called *ice-rafting*, and the boulders are referred to as *glacial erratics*. More than ten thousand years ago during the last ice age, rocks floated on glacial ice as if they were riding piggyback downstream. Sometimes they were even set within or stuck to the base of the frozen slab of ice. Ice floats; rocks do not. After a glacier melts, randomly dropped boulders can be found in locations far off from their points of origin.

Climbers at Donner Memorial State Park near the town of Truckee nimbly ascend to the top of boulders often four times their height. Witnessing a boulderer reach for the small natural handholds of these

giant-sized stones and scramble his or her way to the top makes one wonder where these erratics originated. In this particular area, they stem from the icefields formed at the Sierra crest on Donner Summit and Norden. These glaciers formed and fed the valleys around Donner Lake, Carpenter Valley, and Coldstream. It's important to note, however, that not all erratics are of colossal proportions. They can be categorized in any size range, even pebbles. What makes an erratic an erratic isn't scale; it's travel.

To understand the transportation part, it's key to look at glaciation, which naturally starts with snow. Snow accumulates at high elevations and is compacted into ice. As ice accumulates, the glacier begins to flow from the force of its weight (several thousand feet thick during the last ice age).

Glaciers are like conveyor belts, consistently moving substances downhill. As glaciers move, they pick up small and large chunks of mountains either by breaking off bedrock and plucking material beneath the ice or by collecting rocks that fall from surrounding walls. The ice then slowly carries those chunks downhill until the lowermost tongue of the ice sets them gently down.

Erratics differ from the stockpile debris of moraines and terraces—also glacier remnants. What's left behind as the glacier moves downhill are known as *moraines*. The debris deposited to the side of glaciers is called a *lateral moraine*, which creates ridges. Examples of lateral moraines in the Truckee area include Schallenberger Ridge above Donner Lake and the Trout Creek region—the canyon to the north of Interstate 80. Donner Memorial State Park is an example of a *terminal moraine*, where the glacier stopped. From there, *outwash terraces*—flat areas where streams and rivers deposit coarse sediment downstream of the ice—continue. The Truckee Railyard, Truckee Tahoe Airport, and the flat areas along the Truckee River near the neighborhood of Glenshire are all outwash terraces.

The writings of John Muir, one of the first to document glaciers in the Sierra during his work in Yosemite National Park in the late nineteenth century, are a good place to look to understand the unique nature of erratic boulders. Muir drew rudimentary sketches of Yosemite's glacial activity. Using arrows, he depicted the direction of glacial movement that carved the V-shaped Yosemite Valley and other areas

into broad U-shaped valleys. He noted that as the glaciers retreated, what was left behind was a new landscape: deep chasms, worn or split rocks, and often erratic stranded boulders.

In a 1911 memoir *My First Summer in the Sierra*, about his 1869 excursion to the Sierra Nevada range, Muir described the erratics poetically: "These boulders lying so still and deserted ... no boulder carrier anywhere in sight, were nevertheless brought from a distance. They look lonely here, strangers in a strange land." A glacier, Muir continued, "[dropped] whatever boulders it chanced to be carrying at the time it was melted at the close of the glacial period." In the Sierra, barring the southernmost sixty miles, the glacial period occurred during the most recent ice age, which began 1.6 million years ago and ended approximately ten thousand years ago, according to experts.

Because erratic boulders are carried miles from their source, they're often deposited among rocks that have different makeups. To determine their origin, scientists examine the disparities, comparing the traveled rocks to the home base rocks. Where did an erratic come from? Where are other rocks of the same nature found? Again, erratics are all about

traveling, the Latin term *errare* meaning "to wander." Geologists can also determine the actual direction glaciers flowed by looking at the marks on erratics, known as *glacial polish* and *striations*.

The Lyell Glacier, which Muir studied so closely in the Sierra, is now no longer considered a glacier by scientists because it no longer moves. Instead, scientists call it an ice field.

In his 1894 book *The Mountains of California*, Muir wrote that everything left behind from the moving slabs of ice—granite domes, deep canyons and valleys, and nearly all other features of the Sierra—are glacier monuments. Couldn't we count the erratics right here in our backyard as magnificent stone statues? They remind us of an age long gone, but even more astonishingly, we see, right before our eyes, that era's remains.

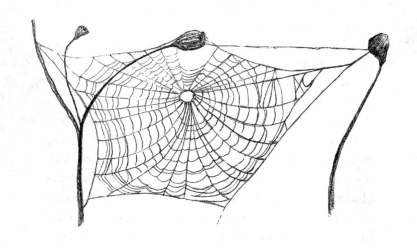

CHAPTER 17

Orb Web

WHILE WE MIGHT think that a chill in the air signals spiders to come indoors, most likely they're already residents. The ones that do live outdoors often remain there, being the cold-blooded creatures that they are; they simply hide in leaf litter, soil, in our woodpiles, or beneath rocks.

Another myth: spiders are insects. Instead, they fall in the class of Arachnida, insects in the class Insecta. Here's the skinny on the differences:

Spider: two body regions, eight simple eyes, no antennae, no wings, four pairs of legs, abdomen unsegmented.

Insect: three body regions, two compound eyes, two antennae, four wings (or two or none), three pairs of legs, abdomen segmented

Another falsehood claims that spiders are venomous. Nearly all spiders do have venom, but out of fifty thousand species (a low estimate, could be much more), a mere thirty to fifty species are exceedingly toxic to humans.

Concerning this arachnid that horrifies most of us, I must confess I'm "that person" who hurriedly grabs a water glass and a piece of paper to capture a house spider and free it outside. Not that I don't want to crush one sometimes, but killing just isn't my nature. The only purpose of my gracious emancipation is to free the eight-legged from the indoors, *my* indoors, quickly. But I wonder—with my arachnophobia (fear of spiders)—if I might consider their water glass detention an educational moment. I am, after all, extremely fascinated by web making.

First, an introduction to a few of the spiders that live in the Sierra. In *The Laws Field Guide to the Sierra Nevada*, author, illustrator, and naturalist John Muir Laws separates thirty-six spiders into five categories according to their web-weaving styles: orb webs (garden spiders), tangled cobwebs (western black widow, false widow, cobweb weaver), sheet webs (hammock spider), running and burrowing spiders (large wolf spider), and jumping and crab spiders (running crab spider and jumping spider). For each group, Laws shares an interesting fact. For example, orb web spiders reconstruct their webs daily. Wolf spiders run down small insects rather than spin webs.

Noticeably, Laws's categorization of web style (among those that create webs), reveals that a spider can be identified simply by its web design. Of course, webs also compound the importance of web building, mainly for capturing prey, which brings me to my more in-depth research. *How do spiders make webs? How does a spider thread reach from one side of a street to the other?*

In my mind, web making is one of the most astounding feats in nature. When I think of a creature producing in its own body the material necessary to catch its prey, it makes me marvel at how clever nature can be.

The process starts (mostly females spin webs) with the spider's abdomen and its silk-spinning glands, known as *spinnerets*. These glands secrete silks, which are composed of rich protein building blocks—amino acids. Within the amino acids is the sequence that makes up the protein that defines each silk gland's function. Each gland, with different types of silk, is created for either web making or another activity, such as formulating an egg sack, creating a drag line to make the frame and radius of the web, or producing the sticky capture line. There are at least seven different silk glands in orb weavers.

In the gland, the protein begins as a liquid gel. As the chain of protein passes through the silk duct, like a narrow tunnel, the liquid is solidified. At the end of each spinneret is a group of nozzle-like structures, like the end of hoses, where a strand of silk emerges from each hole. The spider pulls out the silk at the spigots with its hook-like claws; web-spinning spiders generally have three claws on each leg.

Once airborne, the thread wavers in the wind, a process called *kiting* or *ballooning*.

As the thread drifts, the spider waits until a breeze takes up the thread and the thread attaches itself to an anchor point. Then she walks across the bridge, like a slackliner carefully walking her tightrope.

From the primary slackline (or bridge line) of point A to point B, the spider descends on a looser thread—as if rappelling from the approximate center— which she'll attach to the ground or an object. This forms a Y shape. Back up, she returns to secure radial threads, like spokes on a wheel, from which to create the more in-depth web.

It then starts to create the larger circular net, moving from the outer edge to the center, by attaching segment by segment of additional threads, like

crocheting or knitting one strand of yarn to another.

Lastly, the spider uses the initial spiral configuration, the auxiliary spiral, as a guide to create the *catching spiral*, ejecting the *capture thread*, which she dots with glue. (Under a microscope, orb weaver glue looks like spaced-out beads on a string.) As the catching spiral is made, the *auxiliary spiral* is taken down, much like scaffolding being removed. Along comes her prey—flies, mosquitos, moths, and bees—with little hope of detaching from the tacky substance. But, one might ask, why doesn't this arachnid, who is often on the move, get stuck in her own web? Spiders navigate with the tips of their legs—their tiny hooked claws—so there is little contact area touching the web.

After all this effort, spiders are mindful to repair damages, restoring the structure of the web by reestablishing the tension in the radial threads and/or adding new threads. But all this is so much work for such a short time period! Webs don't last all that long, but, being good recyclers, many orb-weaving spiders eat the protein-enriched silk in their webs, leaving only the main thread of the web intact. The next morning it will weave another web.

Even more remarkable is the fact that spiders build

their webs somewhat blindly. Because their eyes are located at the top of their heads and their legs are located below them, they basically can't see what they're doing. Plus, most build webs in the dark of the night. Only by memory of space, what's situated around them, are they able to create their snares, much as if we were blind but could make our way around our living rooms, knowing where our furniture is placed.

This is a simple explanation of a complicated process, but it's a start for understanding one of nature's ingenious builders. How many times have I walked by a spider's web, sometimes stopping to appreciate the design, yet had no idea of the engineering behind the artistry? Just as we catch many a sea creature with nets, spiders capture their meal with a skillfully knitted web. It's quite amazing! Spiders have their own integrated construction materials and manufacturing know-how. Nature is smart that way, and this is only one example.

Amphibian, Insects

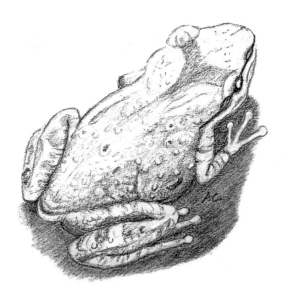

CHAPTER 18

Sierran Treefrog
(Pseudacris sierra)

BY STOOPING LOW to the ground, one can see a completely different environment than the world above. Stamens on a flower, symmetrical markings on a butterfly, or a group of ants marching toward home look completely different from a subordinate perspective. One way to see the micro in the macro is by observing the natural world on its own level, eye to eye.

Case in point. While typing away on my home computer on the second floor one day, I heard a loud *krek-ek, krek-ek, krek-ek* from below, so boisterous, so loud, I was certain a big bullfrog was calling out, announcing its presence. I descended the stairs, opened the door, heard it *krek-ek* some more, and found not a large amphibian but rather a small one, a frog the size of a quarter, an inch or two at most. Squatting down next to the diminutive croaker, I examined it more closely.

The first thing that caught my eye was the frog's

coloring—gray, white, and black—with a wide, black line running from the tip of its nose through the middle of its eyes, or appearing as if through the middle, and ending at the top of its arm. Its speckled skin reminded me so much of a piece of granite that I could easily see how one could mistake this tiny amphibian for a dappled rock. But my noisy neighbor was no small stone but *Pseudacris sierra*, Sierran treefrog, also known as Pacific chorus frog.

Other than its camouflage granite garb, one of the most marvelous characteristics of a Sierran treefrog is its chameleon ability to change color between gray and brown and green over a period of days or weeks to match its environment and the brightness of the background. I once witnessed a vividly lime green Sierran treefrog blending in on a piece of ribbon-like green algae, the algae bending from side to side with each ripple of the slow-moving creek. Had the frog not moved I never would have spotted it. Its camouflage color protects it from predators: wading birds—herons and egrets—snakes, and small- to medium-sized mammals like raccoons and skunks. Even larger frogs will prey on their vulnerable smaller cousin. Nevertheless, while the basic colors

transform, the black stripe that runs from the end of its nose through the center of each eye and along its sides remains the same, regardless of color morphing.

Other standout traits point to its toes and eyes. Its toes are comprised of four rubbery, long, extended fingers, with wide pads at the fingertips. The large toe pads allow it to climb effortlessly and cling to branches, twigs, and grass. Its eyes, clear to yellow with wide black pupils, bulge out of its face.

The "chorus" name stems from the male Sierran treefrog's calls, made by forcing out air, using the larynx muscles in the throat. The sound is amplified by a vocal sac, a thin membrane under the male's throat or at the corners of its mouth. When the sac is inflated, it looks like a piece of bubble gum blown into a big bubble.

Two types of *advertisement calls* are produced by this vociferous frog. One is a two-part *diphasic* (two phases) call, the other a *monophasic* (one-part) call. The two-part is described as *rib-it* or *krek-ek*, the last syllable rising in inflection. This is produced both day and night, often in large male choruses. The one-part, also referred to as the enhanced mate attraction call, occurs day and night as well, but with a shorter and

faster frequency, rising to a higher rate when the male is approached by the female. These calls take place in or near bodies of water, such as marshes, ponds, lakes, reservoirs, slow streams, roadside ditches, and canals, all desirable locations for females to lay their hundreds of eggs—in clusters of ten to eighty—attached to branches or grass in shallow water.

After a busy spring and summer propagating the treefrog species, the noisy amphibian leaves the sunshine and warmth to hibernate in dense vegetation, debris piles, crevices, mammal burrows, and even human buildings. During these colder seasons, the frog's metabolism slows down to save its energy reserves. As with all amphibians, Sierran treefrogs require water at some point in their life cycle (their eggs don't have membranes to prevent them from drying out), so the best time to find them is after it rains.

Sometimes, all we need to do to find the little guy in nature is to take our tallness out. Sometimes, all we need to do is follow what calls, and bend toward the ground. To be in awe is not necessarily to find the grand and to find it at eye level. Sometimes, we simply need to listen and stoop to the ground.

CHAPTER 19

Western Amazon Ant (Polyergus mexicanus)

NATURE CAN APPEAR brutal sometimes. We often cringe when we observe an animal or insect or bird take down another creature. We understand, though, that violent acts are part of what makes nature, nature. But what of slavery? Does slavery exist in the natural world? In the case of Amazon and Formica ants, yes.

Once, on a hot August afternoon, I watched an army of them, carrying what looked like white grains of rice, cross my brick patio and head down into the forest. I followed them to a dead and decomposing tree on the ground, where they walked—more like ran—under the bark, their loot clasped in their jaws. The line was moving at great speed without any interruptions, as if they had a deadline by which they had to deliver their prized goods. Where were they going and what were they doing?

In John Muir's *My First Summer in the Sierra*, published in 1911, he writes: "One is almost tempted at times

to regard a small savage black ant as the master existence of this vast mountain world." Elsewhere he refers to ants as "fierce creatures" and "fearless, restless, wandering imps." I thought it seemed a little harsh to describe such a miniscule insect as "savage" and "fierce"—until I learned how savage they can be.

Little did I know that day I was watching the procession of golden ants, most likely western Amazon ants, that what they were hauling was *pupae*—immature ants encased in cocoons. I also didn't realize that the stolen goods would emerge as slaves to their captors. The slave-making ants (*Polyergus mexicanus* or western Amazon ant) were in the midst of kidnapping babies from their host species, most likely field ants (*Formica spp.*), and transporting them back to a life of slavery in the *Polyergus* colony.

The process from raid to slavery is quite a trajectory,

Amazon raids begin with the workers laying a chemical trail to the Formica ant nest for their fellow raiders to follow. Trails of ants then march to the nest, raid it by using their saber-shaped mandibles as combat weapons, and carry the field ant pupae back to the Amazon home base. Once the kidnapped

field ants emerge in their new captive surroundings, they forage for food and raise the Amazon young. There is no struggle, no rejection of their new role. Once enslaved, the Formica take on the new scent of the nest and behave as if they assume they are home with family.

Another method of obtaining slaves in the ant world involves the newly mated Amazon queen entering a colony of field ants. Once in the colony, she will kill the field ant queen and assume the royal role. Intuitively, once again, the field ants respond by caring for their new leader and her resulting offspring. This cycle of dominance continues as adult Amazons conduct multiple raids in one season with the purpose of replenishing their slave populations. Bottom line of this raid-slave cycle: Amazon ants can't survive without field ants. The Amazon ant "begs" for food—liquids only, *honeydew* (liquid secretions from aphids, scales, and the like) and *insect hemolymph* (blood)—and is only satisfied when a field ant regurgitates sustenance into the Amazon's mouth. These social *Polyergus* don't appear to do anything for themselves other than clean their red-colored shells.

Renowned biologist and naturalist E. O. Wilson

(1929–2021), who studied ants all over the world for most of his life, said that ants will do anything for the good of their colony. In the case of Amazon ants, their reproduction and survival depend completely on invading another colony, stealing its young, and returning home with a new group of future slaves. In Wilson's own words: "Cooperating instinctively is what ants do."

CHAPTER 20

Snow Flea
(Hypogastrura nivicola)

I OFTEN WONDER how many things I've missed by being human, a gentle or not so gentle giant walking upright atop the earth's surface. *What lies beneath the ground I walk on every day? What settles on top? What's been obscured by my straight-ahead point of view?* I've learned quite a lot from my musings but also from different vantages. To gain a variety of perspectives, I look down, bend at the waist, kneel, or sit. This is how I discovered moving dirt, a pile of dust in flux—or seemingly so.

In January, February, and March, especially during the warmer days, I've noticed patches of snow covered with tiny dark specks. The snow appeared even darker in depressions like shoe prints, ski and snowshoe tracks, or tree wells. It's almost as if a car backed up to a snowbank with the engine running and the snow blackened from the exhaust. Or could the ground be showing an early bloom of black-peppered spores? One day I bent down to the ground to take a closer look. The "dirt" was moving!

Turns out, the moving "spores" were snow fleas or *Hypogastrura nivicola*, also known as springtails, six-legged oblong-shaped organisms approximately one-sixteenth of an inch in length. These springtails literally fling themselves into the air with the aid of a "spring" in their tail. They use a *furcular*, a type of catapult attached to their bodies. This trebuchet-like structure has been likened to a retractable two-pronged forked tail (furcular meaning "little fork" in Latin). Tucked under the snow flea's body, it is held in place by a hook-like structure called a *tenaculum*. When the tenaculum is released, the furcular slaps the ground, propelling the springtail into the air, as far as fifty to one hundred times its body length, approximately eight to twelve inches. If a six-foot-tall human had the equivalent of a tenaculum and furcular, that person could be launched into the air and hurled over the three-hundred-foot-tall Statue of Liberty.

Since snow fleas are wingless and don't use their tiny legs to jump like fleas and grasshoppers, the furcular provides their only locomotion, which is essential when they need to "flee" their predators—beetles, spiders, ants, mites, and centipedes. Yet even

though it might succeed in escaping a potential threat, this tiny creature has no control over which direction it's headed or where it eventually lands. Imagine being hurled into space with no sense of where you'll end up!

Despite the name, snow fleas are not actually fleas. Fleas are insect parasites that live on the blood of whatever live creature they can find and bite—a cat, a dog, a human. Snow fleas survive on decaying organic matter such as pollen, fungi, moss, and decomposing leaf litter. In the winter, they congregate at the base of trees to reach the soil where the snowpack is thinner and leaf litter and debris are more accessible. Because they break down natural substances by eating, digesting, and defecating matter, springtails are considered important recyclers.

One may wonder why this tiny gymnast doesn't freeze as it walks about and jumps from snow patch to snow patch, eating its dusty fare. The answer: antifreeze. Snow fleas can withstand bitter temperatures in the winter because they produce glycine-rich proteins. These proteins bind to ice crystals as they start to form, preventing the crystals from growing larger. In other words, snow fleas inhabit their own

antifreeze. But these tiny acrobats aren't solely winter creatures; they hang out in leaf litter the rest of the year or on the surface of ponds.

In the end, a patch of dirty snow might just be a patch of dirty snow. But it's also possible that a congregation of snow fleas is gorging on algae and doing their part as important ecological contributors.

CHAPTER 21

Pale Swallowtail Butterfly (Papilio eurymedon)

IT'S OFTEN BEEN said that as we mature into adults we lose a sense of wonder. We enter an ecosystem without even knowing it, or what's in it, or what kind of relationships are formed. We don't marvel, anymore, at nature and its workings.

If, as defined by *National Geographic Education,* an ecosystem is "a geographic area where plants, animals, and other organisms, as well as weather and landscapes, work together to form a bubble of life," how is it that we have lost our passion for all those bubbles around us, or those we have visited? Glimpses of life exist everywhere, even if we don't look closely.

Butterflies, though, bring that sense of wonder home: how could they not? To see an egg, like a drop of water, set on a leaf, transform into something that can fly. That's magic right there, an astonishing nature narrative. From a cell to additional cells, to a crawling caterpillar, to a brown cocoon hanging from a

thread on a tree branch. Rest. Food. Body parts. A brilliant, colorful winged insect emerges with perfect symmetry. An orange line on one side matches an orange line on the other. A blue circle matches the other blue circle. The black smudge on both wings is exactly the same, symmetrical to a T.

In the Sierra Nevada, there's one butterfly that stands out among the approximate 180 species in the region: *Papilio eurymedon*, or the pale swallowtail.

Its family, Papilionidae, comprises some of the largest butterflies in the world. The pale swallowtail's wingspan measures up to four inches. When I first saw this butterfly, which seemed to float in the air rather than fly, like a feather drifting on a breeze, I marveled at its size, bright colors, and forked tail.

Besides a pale swallowtail's large wings, other identifiers make it an easy mark, primarily its zebra-like black and cream-colored markings with small dots of blue and orange at the back of each wing. The name swallowtail refers to the two narrow-forked projections, one on each wing, extending beyond the back end, much like that of a barn swallow or the split tail of a kite. Two purposes have been projected for these unique "tails." First, they are expendable—like lizard

tails. A predator can grab at them, and if they break off the butterfly can still fly away. The forks also have a specific aerodynamic function, contributing to lift. Thus, one spring day I noticed a swallowtail floating around my yard for quite some time—landing, lifting, landing, lifting.

Its wingspan, the size of my hand from the tips of my fingers to my wrist, is quite large compared to the California tortoiseshell that frequents my yard. As well, the much smaller blue butterflies consistently spotted in my six-thousand-feet neighborhood appear a fifth a swallowtail's size. In other words, the pale swallowtail warrants attention when one focuses on its size and coloration.

Most interesting about the order Lepidoptera (butterflies and moths) is a behavior called *puddling*. For swallowtails, puddling is a man's game. It begins prior to mating season. Young males gather together in puddles, dirt roads or trails, moist soil, mud, or dung, to sip water, nutrients, and salt to incorporate in their sperm for reproduction. The proteins and sodium are passed on to the female during copulation.

Male swallowtails congregate after noticing other individuals inhabiting an area. This presence of

others increases each participant's survival as it finds a reliable water and food source, plus, as a group, the flutter of many individuals in a pool deters predators. Together, as a fraternity, the swallowtails find nutrition and protection.

When not puddling, swallowtails hang out on wildflowers such as lilies and thistles. But before mating and before puddling, these butterflies, like all butterflies, go through metamorphosis. I recount the process here, even though it is a well-known progression, because the transformation of a tiny egg to an airborne creature exemplifies just how extraordinary nature can be.

To begin, the pale swallowtail is single-brooded, meaning it produces one generation of butterflies per year, sometime between June and September. In the Sierra, the female swallowtail lays eggs on host plants such as snowbrush, Sierra coffeeberry, and western serviceberry. Each plant immediately provides food for the hatching caterpillar. The pale swallowtail lays one egg at a time, her total egg production as high as 250 to 300 in a lifetime.

Pale swallowtail caterpillars, or *larvae*, are about two inches long and bright green. With two eye-shaped

markings on the upper thorax and a single yellow band, they look as if there is a separation between the eyes and neck, as if there are eyes looking at you. Behind its head, most swallowtails have a forked wishbone-shaped organ hidden in a slit called the *osmeterium*. When the caterpillar is irritated or disturbed by a predator, the gland instantly pops out like a propelled antenna, emitting a foul-smelling odor.

Caterpillars enter the pupal stage in the fall and overwinter before emerging the following spring. In the *pupa/chrysalis stage*, the pupa begins as green but then turns brown like a piece of bark. When the larva pupates, it secures the tail end of its abdomen to a branch with a silk thread and hangs freely. During this time, the pupa is developing and growing.

Before the final development, the caterpillar releases enzymes that dissolve its tissues. The protein-rich mixture left over from digestion helps aid in the cell division of the cells that survive. The cell groups are called *imaginal discs*. Each of the imaginal discs develops into a part of the butterfly—the wings, antennae, legs, eyes, and all the other features of an adult.

The metamorphosis finalizes when the butterfly emerges nearly mature with long legs, long antennae,

and large wings. It flies away and starts its new, brief journey.

In order to survive, butterflies use a mouthpiece called a *proboscis*, often likened to a straw. The swallowtail extends its proboscis deep into a flower to suck in the water or nectar. When the proboscis is not in use, the butterfly coils the appendage like a party blower that extends out straight and then rolls inward into a spiral.

Papilios can potentially live up to a month, but because they're subject to predators, most live only a week or two. Butterflies are eaten by birds, lizards, mice, spiders, dragonflies, and wasps. One day, I witnessed a dead butterfly being carried off by a column of ants.

Nature is often ephemeral, and we forget that. A spider builds an exquisite web; mushrooms push through firm dirt; a coyote pounces on a vole; three bear cubs wrestle one another; a mountain chickadee stores a thousand seeds; snow fleas jump on the snow; a group of swallowtails puddle to gain nutrients.

Now you see them, now you don't.

An instant can amaze.

Afterword

"So, WHAT IS it about nature you love so much?" a friend once asked. A simple question that should afford a simple answer. But I was confounded. Why *do* I love nature? What does the natural world contribute to *our* world and to us as a group or as individuals? One answer I keep returning to, especially as I've grown older, is an elemental one. Nature reminds me that there is still beauty in this world.

For example, from my kitchen, how many hundreds of hours, collectively, have I stood, looking out the window with binoculars in hand? I watch ten evening grosbeaks visit every day for a month, then suddenly disappear. A baby cottontail hops about, munching grass. A coyote jumps in the air to pounce on its next meal. A black bear mama lumbers into the yard, heading toward a flicker's nest to steal her eggs. Even the sky on a particularly blue-sky day, what I call "Tahoe blue," often stops me in my tracks. How many times have I wanted to linger like a kid in a swimming pool never wanting to get out?

Another reason I am entranced by nature's wonders lies in foreseeing the familiar. Observing what each season holds brings me not only joy but solace in knowing what's to come.

Anticipating robins returning each spring, along with the yips of coyotes, illustrates a consistency, a uniformity I've come to know and depend upon. As well, to see and hear the white-headed woodpecker, beating its beak against the bark at the top of the same white fir at the end of our street. Or simply watching the tip of an icicle melt, drip by drip, when the sun shines bright on its long icy shaft. Nature shows us when one season ends and another begins.

When I return home from my morning cul-de-sac coffee walk or my longer afternoon one or a hike in the meadows of the high country, I might grab a field guide, check out one of the nature apps on my phone, or look something up online. I might even call an expert who studies the thing I just observed and was interested in. One time, after stooping to the ground to witness a raid between two species of ants, I delighted in a back-and-forth exchange with several myrmecologists who taught me about the ants' brutal tactics, a means by which they survive.

The more I learned about the little ants, the more I wanted to learn more.

In learning the natural world, we become familiar with our surroundings, which cements the kinship. But Rachel Carson notes a caveat in her book *The Sense of Wonder*. She is skeptical of "the game of identification" "if it becomes an end in itself." In other words, she discounts nature education if it is not accompanied by "a breath-taking glimpse of the wonder of life."

So, being engaged with nature is twofold. Being in awe, and being educated. Case in point:

On one warm September day, I walk in the woods next to my house. Only a few steps from the pavement I hear a whirring sound, which directs my eye to a buzzing gray papery ball, hanging from a pine tree at my eye level. I stop short, stunned at the large papier-mâché creation. After marveling at the object for quite some time, I return to my house to identify it. An article tells me these paper nests are built by a species called *Dolichovespula*, and they contain "hundreds of cells and workers. Those [nests] on trees [are] sometimes larger than a football." The walls of the nests may have fifteen or more layers of tough

paper, each layer separated by dead-air spaces, thus insulating the nest from heat and cold. The paper is of such excellent quality that it can even be written or typed on. But how is this "paper" created?

The hornet's powerful jaws chew wood and plant fiber into a mass, mixing the mass with saliva. This moist pulp is then plastered into cells for the larvae and into the walls for the nest. In the fall, the new queens leave to hibernate beneath logs or under the bark of dead trees, but the old queen and the rest of the workers die when frost arrives.

Sure enough, upon one of my last visits to the nest, in early winter, I notice no sound. No buzzing. No more swarming hornets. I do see, however, a small speck hanging from the drooping, disintegrating paper ball. Leaning in closer to the circular opening, the size of my small fingernail, I discover a queen, or what I believe to be *the* queen, the ultimate matriarch, hanging frozen at the edge, half her body remaining in the cavity, the other half dangling in the open air. She hangs upon the rim of the nest as if to say: "Here was my life; here was my community; here was my home."

While each day brings new discoveries, routine

turns into familiarity, and with familiarity comes a connection: I *know* this fir tree that invites grosbeaks and nuthatches. I know the first snow plant that appears at the end of May. I know the lupines and paintbrushes, some that line my street, some that fill alpine meadows in July and August. I know the aspens that shed their leaves at the first sign of frost. And right here in my neighborhood, I know the queen bee, her life cycle complete, proudly suspended mid-air at her frozen door.

Acknowledgments

AT SIXTEEN, LORNA Sutcliffe and I spent a month in the winter in Yosemite Valley. That is where it all began, my love of nature. I am forever thankful for that opportunity to be in such grandeur, and to be exposed to the Sierra and its natural history. Something touched my soul then, and that something continues to impress upon me the magnificence of these mountains.

As for those who helped build this book, I would like to thank . . .

First and foremost, Mayumi Elegado-Peacock, co-founder and editor of the independent newspaper *Moonshine Ink*, for accepting my proposal in 2012 to write a column called "Nature's Corner." In it, I explore the flora and fauna in the Sierra Nevada. This collection of essays would not have been possible without her support.

To the professional editors at *Moonshine Ink*—Jackie Ginley, Melissa Siig, Julie Brown, Ally Gravina, Le'a Gleason, Juliana Demarest, and Laura Read—your careful editing and journalistic wisdom always made

my essays better. Juliana took a closer look at one of the drafts, for which I am grateful.

Anne Chadwick, your beautiful illustrations fit perfectly with my vision. They are exactly what I envisioned for *Snow Fleas and Chickadees*. Many thanks for keeping this book in mind, art wise and regarding promotions.

Curtis Vickers, editor of the University of Nevada Press, thank you for your enthusiasm and acceptance of this manuscript and for your professionalism and leadership throughout the process. I couldn't have asked for a better editor. Director JoAnne Banducci, you helped guide me through all the paperwork. Copyeditor Robin DuBlanc, much gratitude for your astute editing and timely communication. Caddie Dufurrena, Marketing and Sales Manager, thank you for keeping the schedule on track. Trudi Gershinov for her work to produce a beautiful cover. Lastly, at UNP, the anonymous peer reviewers who took the time to read and comment on the draft of this project, please accept my deepest appreciation for your encouraging words and for giving credence to my voice.

Those who provided "blurbs" for this book will help make it sail. Thank you!

To all the experts in the field with whom I corresponded, your information—with great enthusiasm—made this project a dream come true.

Kim Bateman, thank you for introducing me to Anne, and for your undying encouragement and wonderful talks throughout the years. David Bunker, many thanks for reading one of the drafts. I greatly appreciate Sue Kloss for having another look at the science. Mike Branch and Cheryll Glotfelty, you two have helped me in many ways through the years, but mostly in believing in me. As well, my "asks" were always met with completed tasks. Ann Ronald and Lois Snedden, your comments and suggestions on one of the early drafts were invaluable. Who better to read the manuscript than two of my favorite hikers? To Joe Medeiros, thank you for all your work in the first few years of this book's inception. Lee Weber-Koch, your marketing skills were most welcome on one of the primary UNP documents. With gratitude to Gary Snyder for granting me permission to include his modest but wise words in the epigraph.

Suzanne Roberts, mentor, cheerleader, Sierra hiking companion, and good friend, you show up, unreservedly, any time I need advice or a talk-through.

Acknowledgments

You are always "there" for me. Laurel Lippert, my cohort in writing, you are the listening ear I count on during our many inspirational breakfasts. Annie Hoffman, you showed me numerous trails in the High Sierra and became my forever nature fan. I miss you and our hikes. Tracy Wager, my fellow camera bug, thank goodness I have you to continually stop with along the trail. To Candy Blesse and Julia Lawrence, you bolstered my confidence along this long journey, and listened tirelessly to every part of this project.

My mother, Marlo Erickson, sent me countless books on the Sierra during my time as a wilderness ranger in the Hoover Wilderness. Coming out of the backcountry after every five-day stint, I couldn't wait to get to the post office to see what books had arrived. With engaging text and stunning photographs—each hardback centered on the Sierra Nevada and its natural history—I was inspired to notice, more attentively, the natural world.

Finally, to my husband, Quiz, and my daughter, Kim. You are the models I look up to as I witness in your own careers the integrity and hard work you put forth in all *your* projects. I love you both to the moon and back, the one that rises high above the Sierra.

Bibliography

Mountain Chickadee

Beedy, Edward C., and Edward R. Pandolfino. *Birds of the Sierra Nevada: Their NaturalHistory, Status, and Distribution*. Berkeley: University of California Press, 2013.

Branch, Carrie (postdoctoral fellow, the Cornell Lab of Ornithology, Cornell University). Discussion with the author, November 2016.

Kozlovsky, Dovid (clinical assistant professor, Department of Ecology, Evolution, and Organismal Biology, Kennesaw State University). Discussion with the author, November 2016.

Pitera, Angela (doctoral student, Cognitive and Behavioral Ecology Lab, Department of Biology, University of Nevada, Reno). Discussion with the author, November 2016.

Pravosudov, Vladimir (foundation professor, Department of Biology, University of Nevada, Reno). Discussion with the author, November 2016.

Wolterbeek, Mike. "Natural Selection and Spatial Memory Link Shown in Mountain Chickadee Research. Long-term, Extensive Study in Sierra Nevada Range Yields Behavior, Memory and Selection Data." *Nevada* Today. College of Science, University of Nevada,Reno, February 12, 2019. https://www.unr.edu/nevada-today/news/2019/mountain-chickadee-brainpower.

Northern Pygmy Owl

Beedy, Edward C., and Edward R. Pandolfino. *Birds of the Sierra Nevada: Their Natural History, Status, and Distribution*. Berkeley: University of California Press, 2013.

Clifford, Garth C. "17 Fascinating Owl Facts You Didn't Know." *World Birds: Joy of Nature*. Last modified August 4, 2021. https://www.worldbirds.org/owl-facts/.

Dickson, Tom. "The Northern Pygmy-Owl Is among the Smallest of North America's Owls, but until Recently Much of Its Life Was a Big Mystery." *National Wildlife Federation*, June 1, 2009. https://www.nwf.org/Magazines/National-Wildlife/2009/Tiny-Terror-of-theSkies#:~:text=%E2%80%9CNorthern%20pygmy%2Dowls%20are%20fierce,%2C%20trying%20to%20kill%20it.%E2%80%9D.

Jarvis, Kila, and Denver Holt, in cooperation with the Owl Research Institute. "Owl Adaptations." In *Owls, Whoo Are They?* Missoula: Mountain Press, 1996. https://www.owlresearchinstitute.org/adaptations.

Lisson, Ryan. "Splitting the Blue Grouse into the Sooty and Dusky Grouse." *Project Upland Magazine*, April 7, 2018. https/projectupland.com/grouse-species/blue-grouse-hunting/blue-grouse-2/.

"Northern Pygmy-Owl." *All about Birds*. The Cornell Lab, Cornell University. Accessed January 2020. https://www.allaboutbirds.org/guide/Northern_Pygmy-Owl.

"Northern Pygmy-Owl: *Glaucidium gnoma*." *Audubon Guide to North*

American Birds. Accessed January 2020. https://www.audubon.org/field-guide/bird/northern-pygmy-owl.

Sooty Grouse

Beedy, Edward C., and Edward R. Pandolfino. *Birds of the Sierra Nevada: Their Natural History, Status, and Distribution.* Berkeley: University of California Press, 2013.

"Sooty Grouse: *Dendragapus fuliginosus*." *Bird Web.* Seattle Audubon Society for Birds and Nature. Accessed October 2019. http://havewww.birdweb.org/BIRDWEB/bird/sooty_grouse.

"Sooty Grouse: Life History." *All about Birds.* The Cornell Lab, Cornell University. Accessed October 2019. https://www.allaboutbirds.org/guide/Sooty_Grouse/lifehistory.

Common Raven and American Crow

Marzluff, John M. (professor of wildlife science, University of Washington). Discussion with the author, May 2020.

Marzluff, John M., and Tony Angell. *In the Company of Crows and Ravens.* New Haven: Yale University Press, 2005.

White-headed Woodpecker

Beedy, Edward C., and Edward R. Pandolfino. *Birds of the Sierra Nevada: Their Natural History, Status, and Distribution.* Berkeley: University of California Press, 2013.

Binns, Corey. "Why Don't Woodpeckers Get Headaches?" *Live Science,* July 16, 2010. https://www.livescience.com/32709-why-dont-woodpeckers-get-headaches.html.

Langin, Katie. "Could Woodpeckers Teach NFL How to Prevent

Brain Injuries?" *Science Magazine*, February 2, 2018. https://www.sciencemag.org/news/2018/02/could-woodpeckers-teach-nfl-how-prevent-brain-injuries.

Laws, John Muir. *The Laws Field Guide to the Sierra Nevada*. Berkeley: Heyday Books, 2007.

"White-headed Woodpecker Sounds." *All about Birds*. The Cornell Lab, Cornell University. Accessed May 2021. https://www.allaboutbirds.org/guide/White-headed_Woodpecker/sounds.

Woodpeckers. *petersonfieldguides*, April 26, 2010. https://www.youtube.com/watch?v=vuAOc6I9jhA.

Coyote

Barrett, Reginald (emeritus professor of wildlife management, UC Berkeley). Discussion with the author, March 2020.

Geese, Eric (research wildlife biologist, USDA/WS/National Wildlife Research Center, Department of Wildland Resources, Utah State University). Discussion with the author, March 2020.

Grass River Natural Area. *Tracking Coyote vs. Dog Tracks*, December 21, 2020. https://youtu.be/g_wvyNtidNs?si=fPqp4FhWbv6dIpKU.

Mitchell, Brian (regional inventory and monitoring division chief, National Park Service, Atlanta). Discussion with the author, March 2020.

American Black Bear

Dunbar, Madonna (resource conservationist, Incline Village General Improvement District; previously Incline Village General Improvement District Resource Conservationist, Black bearSmart Incline Village Program). Discussion with the author, July 2020.

Searles, Steve (wildlife officer, Mammoth Lakes, California Police Department). Discussion with the author, July 2020.

Douglas Squirrel

"Douglas's Squirrel." National Park Service. Accessed November 2022. https:www.nps.gov/articles/000/douglas-s-squirrel.htm.

Muir, John. *The Mountains of California*. Berkeley: Ten Speed, 1977.

Peterson, Roger Tory. *Peterson Field Guide to Mammals of North America*. Boston: Houghton Mifflin, 2006.

Van Vuren, Dirk (wildlife, fish, and conservation biologist, UC Davis). Discussion with the author, October 2018.

American Pika

"American Pika Advances toward Endangered Species Act Protection; Small Alpine Mammal Imperiled by Global Warming." *Center for Biological Diversity*, May 6, 2009. https://www.biologicaldiversity.org/news/press_releases/2009/pika-05-06-2009.html.

Millar, Connie (senior scientist emerita, Forest Service, Pacific Southwest Research Station). Discussion with the author, April 2020.

Quaking Aspen

"Cankers on Trees: Various." Cornell Plant Disease Diagnostic Clinic, Cornell University, College of Agriculture and Life Sciences. Updated March 2015. http://plantclinic.cornell.edu/factsheets/treecankers.pdf.

Rogers, Paul C. (director, Western Aspen Alliance, Ecology Center Associate; adjunct professor, Environment & Society, Utah State University). Discussion with the author, November 2018 and January 2021.

Rogers, Paul, and Darren J. McAvoy. "Mule Deer Impede Pando's Recovery: Implications forAspen Resilience from a Single-Genotype Forest." *PLOS ONE Journal*, October 17, 2018. https://journals.plos.org/plosone/article?id=10.1371/journal.pone.0203619#references.

Rogers, Paul, Wayne D. Shepperd, and Dale L. Bartos. "Aspen in the Sierra Nevada: Regional Conservation of a Continental Species." *Natural Areas Journal* 27, no. 2 (2007): 183–93.

Sisco, Shannon (library technician II, Basque Library, University of Nevada, Reno). Discussion with the author, November 2018.

White Fir and Red Fir

"*Abies concolor*." *U.S. Forest Service*. Accessed September 2019. https://www.fs.fed.us/database/feis/plants/tree/abicon/all.html.

"California Red Fir." *Calscape: California Native Plant Society*. Accessed September 2019. https://calscape.org/Abies

-magnifica-var.-magnifica-(California-Red-Fir)?srchcr
=sc5b692e3a8c2e5.

Woodlands Pinedrops

Laws, John Muir. *The Laws Field Guide to the Sierra Nevada*. Berkeley: Heyday Books, 2007. "*Pterospora andomedea.*" *Botanical Society of America*. Accessed January 2020. https://cms.botany.org/home/resources/parasitic-plants/pterospora-andromedea.html.

"What Are Mycotrophic Wildflowers?" *U.S. Forest Service*. Accessed January 2020. https://www.fs.fed.us/wildflowers/beauty/mycotrophic/whatarethey.shtml.

Zabriskie, Jan (senior museum scientist, Deep Canyon Research Center, Natural Reserve System, University of California). Discussion with the author, January 2020.

Needle Drop

"Facts about Pine Needles." *Sciencing*. Updated November 2019. https://sciencing.com/do-pine-trees-need-survive-6549613.html.

Lanner, Ronald (retired forestry professor, Utah State University). Discussion with the author, January 2019.

"Needle Drop of Evergreens." *Integrated Pest Management*. Utah Pests Extension, Utah State University. Accessed February 2019. https://extension.usu.edu/pests/ipm/notes_orn/list-treeshrubs/needle-drop.

Wohlleben, Peter. *The Hidden Life of Trees*. Vancouver: Greystone Books, 2015.

Shaggy Mane Mushroom

Kuo, Michael. "Coprinoid Mushrooms: The Inky Caps." *Mushroom Expert*. Accessed October 2019. https://www.mushroomexpert.com/coprinoid.html.

"Saprophytic Fungi." *Fungimap*. Accessed January 2020. https://fungimap.org.au/about-fungi/saprophytic-fungi/.

Watermelon Snow Algae

Armstrong, Wayne P. "Watermelon Snow in Sierra Nevada: A Strange Phenomenon Caused by Algal Cells of the Chlorophyta." *Palomar College Arboretum*. Accessed April 2020. https://www2.palomar.edu/users/warmstrong/plaug98.htm.

It's Alive! The High Country Mystery of Red and Pink Snow. Oregon Field Guide OPB, March 11, 2020. https://www.youtube.com/watch?v=QyUML-kgs-8.

Kodner, Robin (associate professor, environmental science, Western Washington University). Discussion with the author, May 2020.

Glacial Erratic

Duane, Daniel. "What Remains." *California Sunday Magazine*, April 4, 2019. https://story.californiasunday.com/lyell-glacier-yosemite/.

Emery, Andy. "Glacial Erratics." *AntarcticGlaciers.org*, October 20, 2020. https://www.antarcticglaciers.org/glacial-geology/glacial-landforms/glacial-depositional-landforms/glacial-erratics/.

Hudson, Jake (civil/geotechnical engineer, Holdredge and Kull/NV5). Discussion with author, June 2022.

Muir, John. *My First Summer in the Sierra*. New York: Penguin Books, 1911.

Orb Web

Bond, Jason (evolutionary biologist and taxonomist, UC Davis). Discussion with the author, October 2022.

Gordus, Andrew (assistant professor of biology, Johns Hopkins University). Discussion with the author, November 2022.

Laws, John Muir. *The Laws Field Guide to the Sierra Nevada*. Berkeley: Heyday Books, 2007.

Miceli, Courtney. "Spider Silk Is Five Times Stronger Than Steel—Now Scientists Know Why." *Science AAAS. Science.org*. November 20, 2018. https://www.science.org/content/article/spider-silk-five-times-stronger-steel-now-scientists-know-why.

Mirus, Rachel Sargent. "How to Spin a Spider Web." *Mountain Times*, October 19, 2022. https://mountaintimes.info/how-to-spin-a-spider-web/.

Real-Life Spider Shoots Web 25 Metres Long! The Hunt. | *BBC Earth*, June 25, 2017. https://www.youtube.com/watch?v=nlRkwuAcUd4.

Sierran Treefrog

Jameson, D. L. J. P. Mackey, and R. C. Richmond. "Sounds of Sierran Treefrog—*Pseudacris sierra*." *CaliforniaHerps.com*, 1966. http://www.californiaherps.com/frogs/pages/p.sierra.sounds.html.

Morey. S. "Sierran Treefrog (Chorus Frog)." *California Wildlife Habitat Relationships*. Updated December 2018. Nrm.dfg.ca.gov,file:///Users/evequesnel/Downloads/lha_A077%20(8).pdf.

"Sierran Treefrog—*Pseudacris sierra*." *CaliforniaHerps.com*. Accessed January 2020. http://www.californiaherps.com/frogs/pages/p.sierra.html.

Somma, L.A. "*Pseudacris sierra* (Jameson, Mackey, and Richmond, 1966)." *U.S. Geological Survey, Nonindigenous Aquatic Species Database*. Revised May 2018. https://nas.er.usgs.gov/queries/factsheet.aspx?SpeciesID=2780.

Western Amazon Ant

Laws, John Muir. *The Laws Field Guide to the Sierra Nevada*. Berkeley: Heyday Books, 2007. *Of Ants and Men*. PBS, September 9, 2015. https://www.pbs.org/video/eo-wilson-ants-and-men-full-episode.

Prebus, Matthew (professor, School of Life Sciences, Arizona State University). Discussion with the author, March 2020.

Torres, Candice (professor, biology department, Tarrant County College). Discussion with the author, March 2020.

Tsutsui, Neil (professor, Department of Environmental Science, Policy, and Management, UC Berkeley). Discussion with the author, January 2020.

Ward, Philip (professor, Department of Entomology and Nematology Department, UC Davis). Discussion with the author, January 2020.

Snow Flea

Gibb, Timothy J. "Snow Fleas: Winter Insect Insanity." *Purdue University*, February 4, 2020. https://extension.purdue.edu/article/36067.

Graham, Lin F., R. Campbell, and P. Davies. "Structural Modeling of Snow Flea Antifreeze Protein." *Biophysical Journal* 92, no. 5 (2007): 1717–23.

Hetzler, Paul. "No Need to Flee from These Fleas." *Cornell Cooperative Extension of St. Lawrence County*. Paul Hetzler Essay Series. Accessed September 2019. http://stlawrence.cce.cornell.edu/agriculture-natural-resources/paul-hetzler-essay-series.

Pearson, Gwen. "Snow Fleas." *Wired*, January 14, 2014. https://www.wired.com/2014/01/snow-fleas/.

"Snow Fleas: Helpful Winter Critters." *Ecological Society of America*, January 28, 2011. https://www.esa.org/esablog/2011/01/28/snow-fleas-helpful-winter-critters-2/

w*Snow Fleas: The Unsung Heroes of the Natural World. Back to Reality*, March 24, 2017. https://www.youtube.com/watch?v=8BOIpiua_z4.

The Springtail. BBC's Life in the Undergrowth, January 24, 2010. https://www.youtube.com/watch?v=OwOL-MHcQIw.

"Springtails: Collembola." *Encyclopedia Science*. Accessed January 2020. https://www.encyclopedia.com/science/encyclopedias-almanacs-transcripts-and-maps/springtails-collembola.

Pale Swallowtail Butterfly

Shapiro, Arthur M. (distinguished professor, Department

of Evolution and Ecology, College of Biological Sciences, Center for Population Biology, UC Davis). Discussion with the author, April 2020.

———. "*Papilio eurymedon.*" *Art Shapiro's Butterfly Site.* Accessed April 2020. https://butterfly.ucdavis.edu/butterfly/papilio/eurymedon.

About the Author and Illustrator

EVE QUESNEL (AUTHOR)

Eve is the co-editor, along with Cheryll Glotfelty, of *The Biosphere and the Bioregion: Essential Writings of Peter Berg*, and co-author, with Leticia Aguilar, *of Leaving Patriarchy Behind: One Woman's Journey*. Her other publications include essays in two natural history anthologies, *Tahoe Blues* and *Wildbranch: An Anthology of Nature Environmental, and Place-Based Writing*. Every few months, in hopes of educating her community (and herself), she researches a plant, animal, bird, or other phenomenon for her column "Nature's Corner" in the North Lake Tahoe–Truckee newspaper *Moonshine Ink*. Eve is a Truckee, California resident whose passion for the natural world lives on in the Sierra Nevada.

ANNE CHADWICK (ILLUSTRATOR)

An author, illustrator, and photographer, Anne is a leader in several organizations (including board chair of Point Blue Conservation Science) devoted to protecting the environment and advancing the arts. *Pacific in My Soul: Reflections of a Coastal Nature,* combines her passions for photography, wildlife, and creative writing. *Splitting Heirs* is a 1923 courtroom drama novel set in Los Angeles and France. Anne splits her time between Sebastopol, California, and Vancouver, British Columbia.